Portrait of

CANYON COUNTRY

Portrait of America Series

Happy trip —
Take some pictures like
these.

Love
Diana
+
Linda

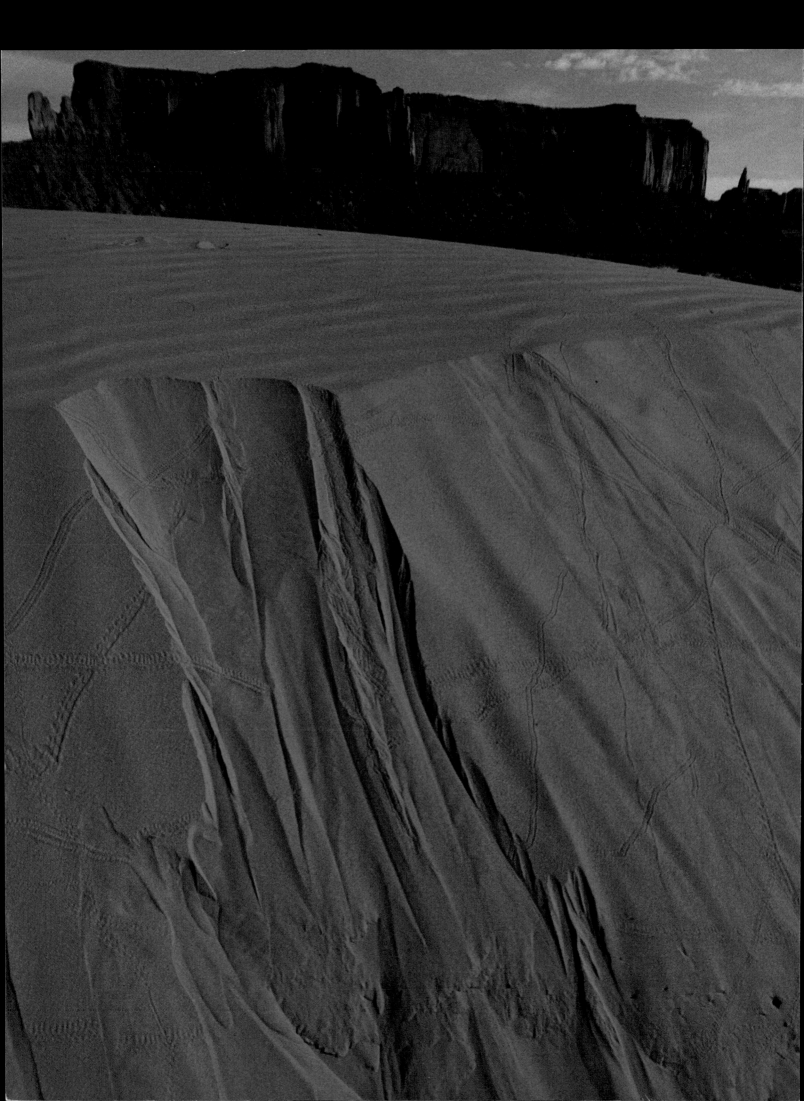

Portrait of

CANYON COUNTRY

PHOTOGRAPHY BY DEWITT JONES
TEXT BY STEPHEN TRIMBLE

GRAPHIC ARTS CENTER PUBLISHING COMPANY
PORTLAND, OREGON

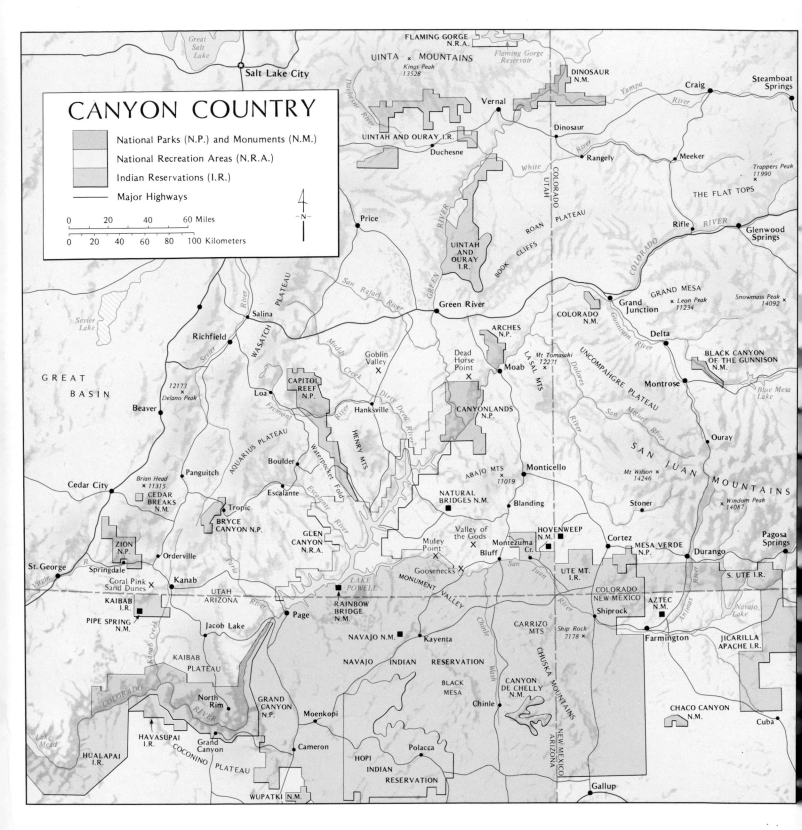

CANYON COUNTRY

National Parks (N.P.) and Monuments (N.M.)

National Recreation Areas (N.R.A.)

Indian Reservations (I.R.)

Major Highways

0 20 40 60 Miles

0 20 40 60 80 100 Kilometers

N

International Standard Book Number 1-55868-025-X
Library of Congress Catalog Number 90-80210
© MCMXC by Graphic Arts Center Publishing Company
P.O. Box 10306 • Portland, Oregon 97210 • 503/226-2402
Printed in the United States of America

Frontispiece: Twin symbols of the Canyon Country, red rock and desert sands form a geologic circle of creation and decay at Monument Valley. The valley lies at the geographic center of the 130,000-square-mile Colorado Plateau.

VOICES FROM THE SIX DIRECTIONS

The sun rises. Navajo people pray to the white dawn, to Grandfather Talking God. They thank the Holy People for life, for placing them in this land bound by sacred mountains, this land of rivers and deserts and canyons. They offer a pinch of sacred cornmeal to each of the six directions: to the east; to the south; to the west; and to the north; to that point in the heavens most distant above, the zenith; and to the point in the earth most distant below, the nadir.

From these six directions they hear the voices of their Holy People, the land, the plants, and the animals. The voices tell the stories of Canyon Country.

To learn the stories of Canyon Country, I traveled to the six directions. I listened to the land and to its people.

The voices of the Canyon Country speak to us all. They come first at dawn, from the east.

FROM THE EAST

The glitter of stars in a blue-black sky dims. The palest of daylight colors the rim of the rock below Delicate Arch. Slowly, softly, the sun meets the horizon and brushes the stone landscape with a wash of orange-red.

The arch, a bold strut of sandstone, breaks the sky in two. Beyond the Colorado River, the highest peak in Canyon Country—the La Sal Mountains—rises toward the flaring sun. Here in Arches National Park, in southeastern Utah, this single view captures the essences of the Canyon Country: red rock, river, island mountains, and the squared-off angles of mesas and plateaus everywhere between.

This is the Colorado Plateau. It begins where the Colorado River spills out of the Rocky Mountains in western Colorado and ends where the river leaves the Grand Canyon and enters the Mojave Desert in western Arizona. Between these points, the Colorado and its network of tributaries carve through 130,000 square miles of flat-lying rocks in the Four Corners states of Colorado, New Mexico, Utah, and Arizona.

Open basins, tabletop mesas, and arid badlands contribute to this plateau landscape. Green forests and blue mountains provide respite from the ocean of red rock. But at the heart of the Colorado Plateau are the canyons—carved deep by the myriad rivers and smaller tributaries—and the great amphitheaters and gorges of Bryce and Zion, etched into High Plateaus marking the region's western boundary.

Canyon Country begins with the greatest of its rivers, the Colorado, flowing east from Rocky Mountain National Park. It meets first with the Gunnison River at Grand Junction, Colorado. "Grand" refers to the old name for this upper stretch of the Colorado, which joins the Green River in Utah. Not until 1921 did the Colorado State Legislature secure the right to call the whole river stretching from the mountains to the sea by one name.

The Gunnison River leaves the Rocky Mountains southeast of Grand Junction, near Montrose. Here it has carved a gorge through the dark, ancient Precambrian gneiss. The Painted Wall, tapestried by light-colored volcanic dikes, rises twenty-three hundred feet above the river in the shadowed Black Canyon. The Gunnison, checked by growing volcanic mountains to the north and south, cut down through the tough rock over two thousand feet. Tributaries could not keep pace, so the Black Canyon today is both deep and narrow, measuring only thirteen hundred feet across at the Narrows.

The Colorado flows past its confluence with the Gunnison and passes around the north end of the Uncompahgre Plateau. Here, small red-rock canyons slice through the tip of the Uncompahgre. Colorado National Monument protects these canyons primarily because of the single-minded efforts of "crazy" John Otto, "the hermit of Monument Canyon."

Otto came to the cliffs above the green fields and orchards of Grand Valley in 1907 and quickly became obsessed with the place. He lived among the sandstone monoliths and canyons for thirty years, building trails and promoting in a stream of letters to editors and politicians what he called, "the highest class Park Project in all Creation." In 1910, the land became a national monument, protected by law.

In 1922, down the Colorado from Otto's haunts, near Moab, Utah, Hungarian immigrant Alexander Ringhoffer prospected the slickrock sculpture garden that is known today as Klondike Bluffs. He found no minerals, but the rocky scenery so impressed him that his efforts eventually led to Arches' designation as a national monument in 1929 and as a national park in 1971.

Freestanding arcs of stone are called natural bridges if they span a watercourse, arches if they do not. Arches can form on the edges of cliffs, where a pothole grinds through, or when an alcove in a fin deepens, piercing the wall, but reasons for the concentration of natural stone spans at Arches National Park are more complicated.

Uplift during the last ten million years has raised the great island of flat rocks that forms the Colorado Plateau to an average elevation of five thousand feet, with some plateaus and island mountain ranges reaching twice that height, despite erosion. In places, rocks bent and fractured along lines of weakness. Sharp breaks or faults raised plateaus and dropped valleys. Bends created S-shaped monoclines, larger upwarps, or dome-shaped anticlines. Sometimes, rocks shattered in parallel cracks and joint systems.

Such joints laced Arches' Entrada Sandstone. Salt flowing deep underground domed up the sandstone layers above and made joints. Uplift and erosion continued, layer after layer washed away, and when groundwater dissolved the salt, the domed layers above collapsed, further fracturing the joints. Rain and winter ice accentuated the cracks, leaving fins of sandstone standing high between them. Holes eroded through the fins. Small windows grew into arches.

Salt—three thousand feet of it—deposited in a drying inland sea 300 million years ago, underlies most of southeastern Utah. It has helped form erosional fantasies south of Arches as well, in Canyonlands National Parks.

Canyonlands was Bates Wilson's park. For fifteen years he spent his days off from his job as superintendent of Arches exploring the rough country to the south and promoting its importance to all who would listen. He became a master of public relations and Dutch-oven camp cooking—sometimes performing both at once when entertaining politicians in the backcountry. When he won over Stuart Udall, Secretary of the Interior under President John F. Kennedy, events moved quickly, and Canyonlands became a national park in 1964.

Bates repeatedly rejected official plans for developing Squaw Flat Campground in Canyonlands; he did not want a rock touched. Finally, exasperated planners told him to do it himself, and Bates proceeded to do just that, carefully laying out campsites between junipers and fins. Today, the campground is one of the most soothing in Canyon Country.

Canyonlands' high mesas look out over the canyons of the Colorado and Green rivers, joined deep in the stone labyrinth below Dead Horse and Grand View points. Halfway down lie the benchlands, encircling north of the confluence by the hundred-mile-long White Rim jeep road. On the west side of the confluence is The Maze; on the east, The Needles.

Beneath The Needles, the entire salt bed deep within the Paradox Formation is moving towards the Colorado River, tugging at surface rocks. The overlying layers break under the stress and form the straight-sided valleys called The Grabens. Rangers have seen check dams for stock tanks breached and roads made impassable by fresh earth movement between jeep trips to the area.

The array of fins in Canyonlands and Arches creates landscapes of sandstone hoodoos and hobgoblins, winding joints and slots, whose names sum up their whimsical, elaborate architecture: The Maze, Lost Canyon, Devil's Garden, the Fiery Furnace, The Windows, The Doll House.

Aridity keeps the rocky tablelands free of dense vegetation and soil. Juniper and piñon pine survive among the rocks; grasses and desert shrubs—blackbrush and saltbrush—grow in the sandy swales between. The rivers are fed by snowmelt from the distant Rockies, and ephemeral streams run only in flood, sweeping erosional debris toward the sea.

FROM THE SOUTH

Indian voices come from the south—the Navajo, the Pueblo, and the Anasazi, ancestors of the Pueblo people. On Colorado's Mesa Verde, the Anasazi voices ring pure. Along the San Juan River and in the smaller canyons farther south—the Tsegi, Canyon de Chelly, and Chaco Canyon—the three voices mingle. In Monument Valley, they murmur in the wind that blows around red mesas and buttes.

The Colorado Plateau extends farther south, but badlands and sweeping desert grassland replace canyons as the defining landscapes. Canyons like Chaco lie small and isolated in a huge plateau under an even bigger sky. Canyon de Chelly hides within the flanks of the Chuska Mountains. But it is Monument Valley with its isolated mesas that symbolizes the southern Canyon Country.

Once, the monuments-to-be were connected within a broad plateau. As stormwater ran down through the joints between blocks, slots widened, and mesas detached from the ends of the plateaus. Wider than they are high, mesas eroded to buttes, which are higher than wide, and then to monuments—narrow spires fated to topple.

From a distance, Monument Valley looks horizontal. The mesas stand in rows, separating earth and sky. At the base of the Totem Pole or the Mittens, the valley turns vertical, the walls of the mesas as sheer as any canyon.

For the Hopi, it is not Navajo Country at all. Hopi people lived in northern Arizona for thousands of years before the Navajo came. The Hopi, pueblo-dwellers like the Anasazi before them, maintain an intimate and intense relationship with the land around their villages. The Navajo, who have surrounded them, call themselves *Diné*, The People.

Today, *Diné Bikéyah*, or Navajo Country, stretches across the southern third of Canyon County. The Navajo Reservation spans twenty-five thousand square miles, nearly one-fifth of the entire Colorado Plateau. The sacred mountains tie the land together, above dun and tan and rust-colored mesas. Here, according to Navajo legend, Father Sky meets Mother Earth; here the two match in scale.

Steven Darden, a young Navajo who has served on the Flagstaff, Arizona, City Council, explains it like this:

> Here is Father Sky, pressing right there, united with the earth. . . . There is that union, Mother Earth and Father Sky. They are complementary; they generate life. That's the Navajo way.

Sometime before 1600, the Apacheans moved south from Canada and Alaska. Most Apacheans were nomads, but one group incorporated more of the Pueblo lifeway, started farming, and became the people we call the Navajo.

In 1539, the Spanish entered the Southwest. They brought the Indian difficulty and death, but they also brought the horse, and the Apacheans became the first mounted Indians north of Mexico. When Pueblo people sought refuge with the Navajo after their rebellion against the Spanish in 1680, Pueblo weavers added to what Spider Woman had taught the Navajo. The result has been remarkable rugs with noble names like *Two Grey Hills* and *Wide Ruins*.

Two hundred years of alternating peace and warfare between Navajo raiders and Spanish, Mexican, and American settlers followed the Pueblo Rebellion. Then, in 1863, the

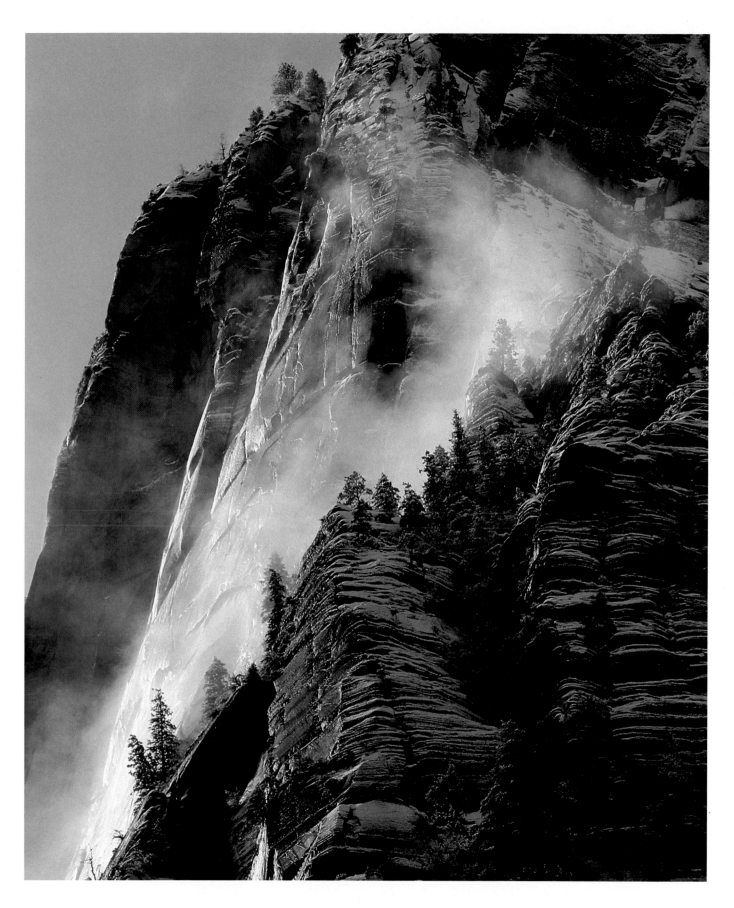

A late March snowstorm dusts the Great White Throne, a prominent landmark in Zion National Park. In the High Plateaus above Zion, average precipitation is twenty-five inches per year.

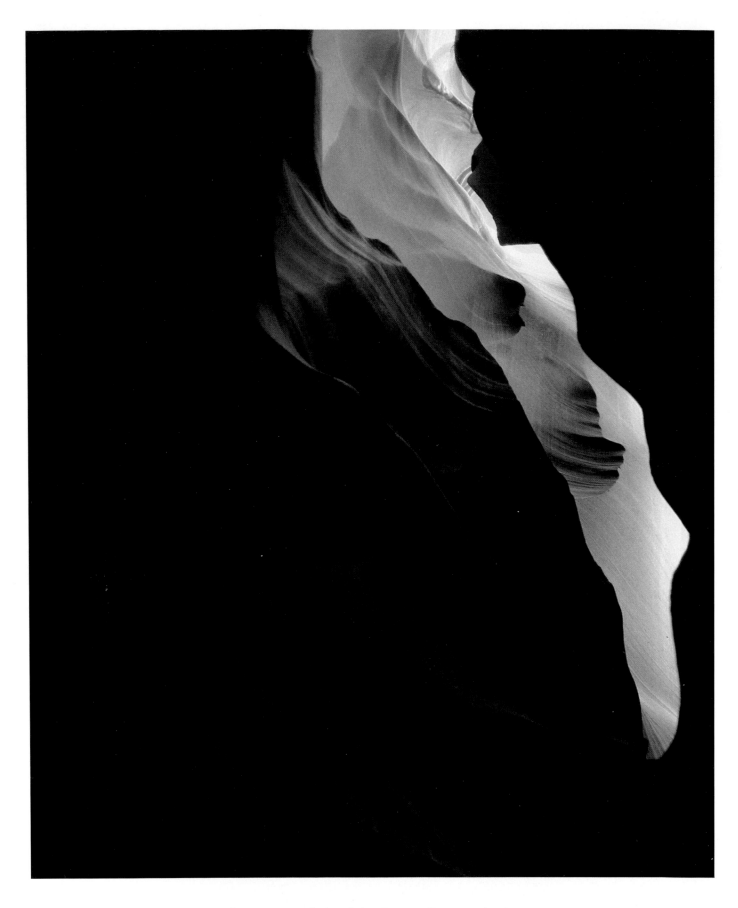

Water, the master sculptor of the Canyon Country, slowly carves away at soft sandstone rock and creates a range of graceful forms and shapes. The fluted walls of a sandstone slot near Glen Canyon exhibit the work of an intermittent stream.

United States Army delivered the final, harsh blow to Navajo freedom. Kit Carson penetrated the heartland of Navajo Country, Canyon de Chelly, home of Anasazi ruins and Navajo gods. He killed few Navajo compared to the Spanish, but he destroyed the crops and herds of the *Diné* at the beginning of winter, and the starving Navajo surrendered.

Fully half the tribe spent the next four years in disastrous captivity at Fort Sumner in eastern New Mexico. The rest escaped westward, deeper into the canyons. Finally, in 1868, the exiled Navajo returned home and began to build the modern Navajo nation.

After World War II, Ed Smith moved with his new bride to Oljato. With a twinkle in his eye, he describes how the trading business worked until, "Everything turned to cash all the way around."

You bought the groceries on credit. You traded the groceries for rugs, for sheep, for anything. If a guy killed a coyote, he'd bring the coyote skin in to you. You'd say, well I wonder how . . . much I can get for this. . . . Then you sent that back to where you bought the groceries; they figured the valuation and credited your account. It was just a big guessing game, but it was kind of fun. You didn't make any money. If you didn't like living there you were wasting your time. . . .

* * *

Summer solstice. Shafts of light illuminate ancient drawings carved into stone. At Chaco Canyon, New Mexico, a dagger of light appears at noon. Hovering above a spiral petroglyph, the light moves downward, passing through the center of the spiral. These sun calendars mark solstice and equinox. They are hundreds of years old. We call the people who made them Anasazi—the prehistoric Pueblo people.

For many centuries, Anasazi planted crops when solar calendars said the time was right. Then the canyon dwellers moved on, restless, their fields depleted.

The Anasazi people developed their most sophisticated culture between 900 and 1150 A.D. at Chaco Canyon, where the great pueblos stood four and five stories high, with hundreds of rooms surrounding large ceremonial structures called great kivas. They developed water-control systems, to divert runoff from summer storms to their terraced fields. But by the late 1200s, they had abandoned Chaco.

Mesa Verde and the northern San Juan River country saw a second flowering of Anasazi culture. But unlike Chaco, this area never showed formal community organization; it was simply a complex of pueblos.

The cliff houses of Betatakin and Keet Seel in the Tsegi canyons of Arizona's Navajo National Monument also developed late in the 1200s. Their people, the Kayenta Anasazi, lived in alcoves of golden Navajo Sandstone for only a short time. Leaving Mesa Verde and the San Juan drainage—including the Tsegi—by 1300, the Anasazi had abandoned many other traditional homelands by 1450.

Today, the ruined pueblos at Chaco Canyon stand as a monument to the Anasazi culture. Elsewhere, remnants of great pueblo civilizations are often concealed by vegetation, inundated by silt, or disguised by modern civilization. But at Chaco, the arid climate has preserved the ruins.

Archeologists Michael Marshall and John Stein describe Chaco as a "Mecca-like" place of pilgrimage, the center of a sacred landscape—all integrated with mythological history.

If Chaco was the center of the twelfth-century Anasazi world, Pueblo Alto was its sentinel and gateway. Although the Anasazi had no wheeled vehicles, at least five ancient roads converge here, on the north rim above the canyon.

In autumn, northward from Pueblo Alto, the world falls away in a mosaic of earth-tones. The Great North Road is a subtle grassy path between darker rows of winter saltbush.

The great kiva of Casa Rinconada is an observatory, a receptacle for solstice sunbeams. The canyon is a compass, laid out east-west, the sun track's annual shift across the sky, a major event, linked to what architects call sacred geometry. Lookout posts mark promontories; shrines and tower kivas punctuate the straight lines of prehistoric roads.

John Stein says: "We don't yet know what the prehistoric roads were used for. But there is no other Chaco Canyon in the Anasazi world. All roads lead to Chaco."

FROM THE WEST

The voices from the western Canyon Country are Mormon voices: Rancher Met Johnson says, "In southern Utah, I feel culturally enriched. Here I feel like I have a heritage of two hundred years. If I go someplace else, I feel like I'm just barely a day old."

Southern Utah is slickrock and Mormon country. It begins abruptly, at Zion. The cliffs and temples above the canyon, the lunar knobs and massive buttes around Checkerboard Mesa—these are mountains of sandstone carved from what feels like a single block of earth.

The most impressive of these mountains is the symbol of Zion National Park, the Great White Throne. When it rains, mists lower and swirl around the monolith, parting to expose polished white stone. The quality of the stained desert varnish deepens when it is wet, but never reveals the summit.

Everything in Zion matches the grand scale of the Great White Throne. Full-sized pine and fir grow on the ledges. The Virgin River spills down year-round from the eleven thousand-foot summit of the Markagunt Plateau. The Virgin carves through Navajo Sandstone. In the Narrows, it runs at its steepest gradient—130 feet per mile. Zion Canyon is carved out of one of the High Plateaus of western Utah, a barricade standing over eleven thousand feet high.

The deepest canyons exist where the rivers cleave high plateaus: Zion Canyon in the Markagunt Plateau, the Paria River Narrows in the Paria Plateau, and the Grand Canyon of the Colorado within the Kaibab Plateau. Between the plateaus and the Colorado in Glen Canyon, tributary streams wind through deserts and cut through the occasional upwarp among flat-lying rocks. These streams dissect huge expanses of sandstone into a fretwork of slots, rims, domes, and reefs.

A half century ago, a young, romantic wanderer named Everett Ruess came to slickrock country with his burros to explore "southward to the Colorado, where no one lives." However, in 1934, Ruess vanished in the canyons. Before his disappearance, he sent a last letter to his brother. He was writing from south of Escalante, "on what seems like the rim of the world":

I prefer the saddle to the streetcar and star-sprinkled sky to a roof, the obscure and difficult trail, leading into the unknown, to any paved highway, and the deep peace of the wild to the discontent bred by cities. Do you blame me then for staying here, where I feel that I belong and am one with the world around me?

These canyons still offer the same peaceful isolation, never settled and barely used, even by the Mormons. Today, Lake Powell drowns their lower reaches, but remaining canyons are still places "where no one lives."

In 1847, Brigham Young brought his flock to Salt Lake City, and within ten years established the Church of Jesus Christ of Latter-day Saints in their new state of Deseret. The Mormons came to this wilderness to escape persecution, and the church remained single-minded about making their domain permanent. They colonized southward along the base of the Colorado Plateau to St. George and what they called "Dixie"—a southern outpost where they grew cotton, made wine, and ministered to Paiute Indians.

The 1860s were difficult, as the Mormon frontier jarred hard against the Navajo moving north to escape the U.S. Army. By 1876, tiny Mormon towns had begun to spread. Cannonville, Henrieville, and, later, Tropic were established in the Paria Amphitheater below Bryce Canyon. Escalante and Boulder took root on the upper reaches of the Escalante River. In 1880, with the settlement of Hanksville, irrigation facilities reached a limit.

To reach Hanksville, the villagers had to pass through Capitol Reef, named for the barrier of sandstone that felt as absolute as an ocean reef. Passage here was not over or past the reef, but *through* it in the deep narrows of Capitol Gorge. Today's highway curves easily with the Fremont River through Capitol Reef National Park.

The reef forms the steepest face of the Waterpocket Fold, a monocline that stretches south for almost one hundred miles to the Colorado River. Its summit of Navajo Sandstone contains the symmetrical domes and waterpockets that give the place its alternate names.

From the top of the fold, light fills the sky, bounces from the rocks, and penetrates into the deepest of side canyons, where it reflects between the walls so many times it seems to acquire the density and color of well-aged bourbon. What is not rock is light. The moon illuminates the country almost as brightly as the sun. Everywhere is slickrock and light.

* * *

In some places in the West, the Frontier ended in 1880. But not in southern Utah. The Church of Latter-day Saints had not yet pushed past the Colorado to the San Juan, and despite Brigham Young's death in 1877, colonization remained a divine imperative. An amphitheater near the rendezvous point at Forty Mile Spring, proved a fine place for fiddles and has been called Dance Hall Rock ever since.

Once the trip started, however, there was no time for dancing. Silas Smith and Platte Lyman led more than two hundred fifty people through six months of heroic labor in a "short cut" across incredibly difficult terrain to found Bluff on the San Juan River. To ford the Colorado, they blasted a road into Glen Canyon. The task took six weeks, the time they had alloted for the entire trip.

They had aimed for Montezuma Creek, but when they reached the San Juan River in April, 1880, just eighteen miles from their goal, they ground to a halt. Cottonwood Wash might wash away their fields, the San Juan might flood their homes, but they would go no farther.

The year 1880 now lies more than a century behind us, but that century has brought less change to southern Utah than to most places. The owner of the Cedar City Livestock Auction, Met Johnson lives half the year on a thirteen thousand-acre ranch up the East Fork of the Sevier River, north of Bryce, and spends the other half along a curve of asphalt in a Cedar City subdivision.

Wilderness still exists here—in national parks, in empty public lands, and on the rangelands where ranchers make their living. Met Johnson says:

I like to work hard and be alone and be out. . . . I think it cleanses your mind and your attitude and your soul. I think it cleanses your ambition. It's like taking a real good X-ray of yourself. . . .

You can't hardly even be with anybody because the only thing you can take to that experience is yourself. When your soul touches whatever it touches, it cannot be limited. You can't have a boundary of how long you'll stay or how cold you feel or how hot you'll feel. If you try to control any of the elements . . . then you interrupt the message.

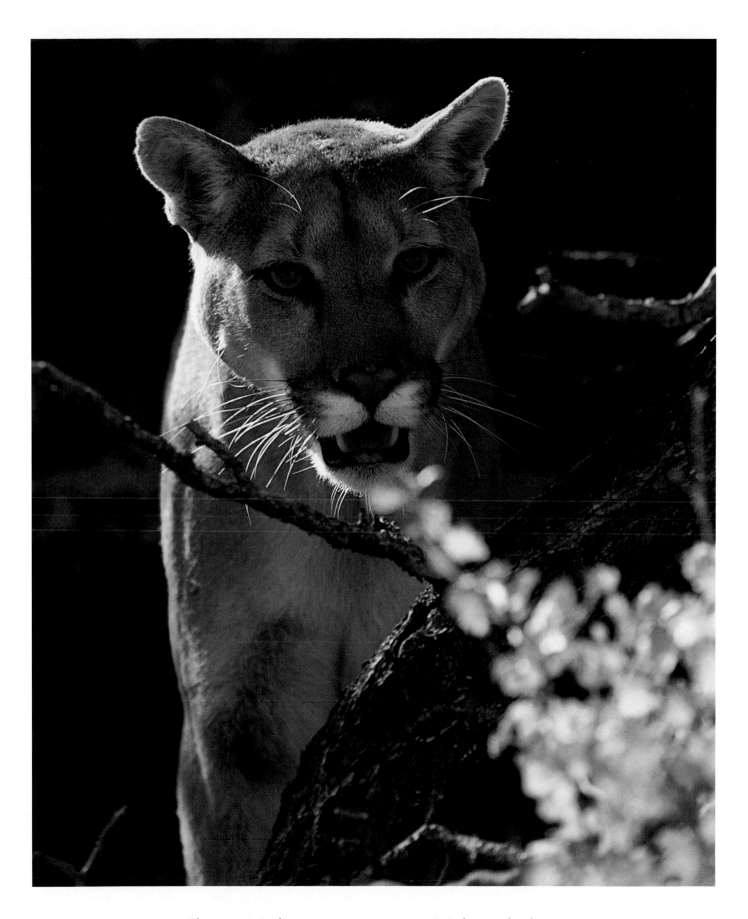

The mountain lion—or cougar or puma (it is known by forty common names)—roams throughout the Canyon Country but is rarely seen. Shy and primarily nocturnal, the cougar feeds on deer, foxes, rabbits, mice, and occasionally livestock.

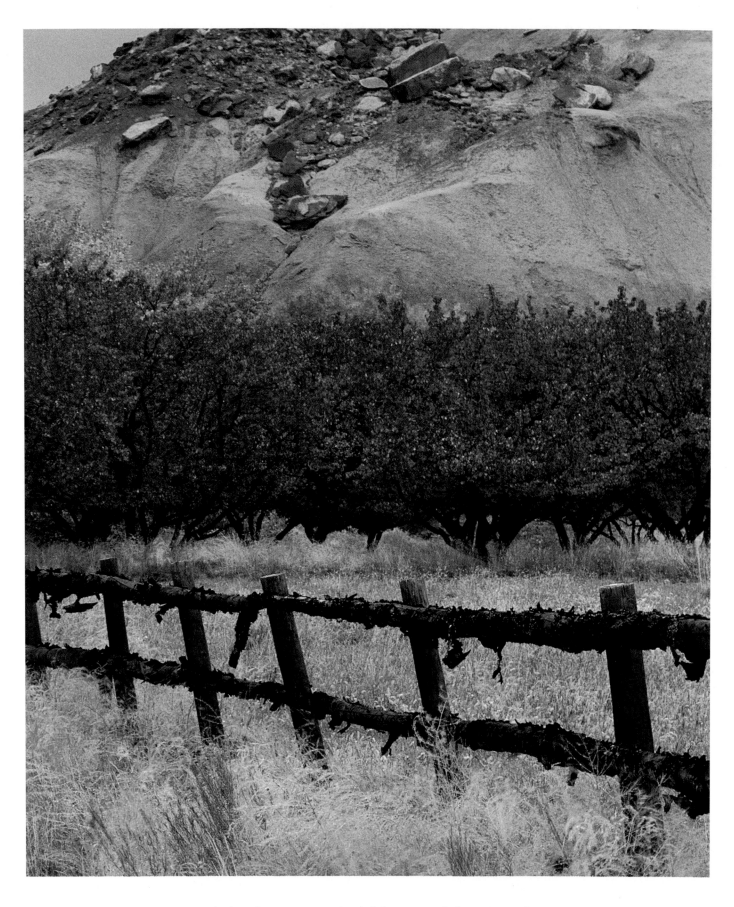

Long before the Mormons planted the area with fruit trees, others were drawn to this fertile watershed of the Fremont River. The Fremont Indians inhabited the area around Capitol Reef from approximately 950 A.D. to 1200 A.D.

FROM THE NORTH

From the north flows the Green River. It carves off the eastern end of the Uinta Mountains at Dinosaur National Monument, rolls peaceably through the Uinta Basin, and then enters the Tavaputs Plateau, breaching the Book Cliffs at the town of Green River. Farther south, the Green runs into the canyonlands toward its confluence with the Colorado.

The river bubbles and froths and rolls. Though the mountain men called it by the Crow Indian name *Skeedskeedee,* in Utah, the language the river speaks is Ute.

The Ute Nation once embraced the Colorado Rockies and eastern Utah from Salt Lake City to Denver, from Wyoming to New Mexico. "The Utes belong to the mountains," says Clifford Duncan, the director of the tribal museum at Fort Duchesne, Utah, at the foot of the Uintas.

I could never live anywhere else. I identify myself with the mountains. To me, landscape is a compass, it helps to keep me where I'm at. When I go to Kansas or Oklahoma, where there's no mountains . . . there is nothing there to control you. All I have to do is look up at the mountains to know where I am.

Both mountains and streams help to define the spirit of the Utes. Clifford explains why:

Water from here, streams coming from this mountain, will be different from that water that, say, is coming from Wyoming or the Plains or the Southwest. I am part of this water. If you give me another water, it changes the chemistry of my body, and I get sick. It changes the way I think, too. So that's why we say water is sacred to us. It gives life.

The water of the Green River forms a major barrier to travel in the northern Canyon Country. Only two major crossings exist even today, near Vernal in the Uinta Basin and at Green River at the base of the Book Cliffs.

The northernmost canyons lie in Dinosaur National Monument, where the Yampa River joins the Green, and the augmented river hews its way through Split Mountain and out into the Uinta Basin. The Green River flows past the dinosaur quarry where Earl Douglass first chipped out seven *Brontosaurus* vertebrae in 1909.

These bones, about 150 million years old, were found in the Morrison Formation. Deposited in the Jurassic period, the Morrison Formation crops out in many places, but the Douglass quarry is one of the richest in fossils. Early dinosaur fossils are found in the Chinle and Kayenta formations in Arizona's Painted Desert and Navajo Country. Bones from the giant reptiles come from the Fruitland-Kirtland formations in New Mexico's San Juan Basin.

Fifty million years after Chinle time, the dinosaurs had come to dominate the earth. Morrison dinosaurs ranged from graceful birdlike animals just four feet long that probably lived on lizards to the huge *Brontosaurus, Diplodocus, Stegosaurus,* and *Allosaurus.* (*Brontosaurus* and the fierce carnivore *Allosaurus* have been renamed *Apatosaurus* and *Antrodemus,* but the older names remain better known.) A few miles east of Dinosaur National Monument, new discoveries not yet fully studied have yielded the largest dinosaurs of all—"*Supersaurus*" and its allies. When walking the tropical Canyon Country world of the Jurassic period, they must have weighed more than a hundred tons, twenty times heavier than a modern elephant.

At the Douglass quarry, carcasses had accumulated on a sandbar in a shallow Morrison river where they washed aground. Working through this tangle of skeletons from thirteen species of dinosaurs, Douglass shipped almost three hundred tons of fossils to Pennsylvania's Carnegie Museum.

During fifteen years of work, Douglass saw the quarry achieve national monument status. He and his wife, Pearl, spent the first long winter huddled over their cook stove by night, reading aloud the reports of the early Canyon Country geologists, John Wesley Powell and his compatriots. Later, they built a house, settled in, and raised prized vegetables.

Today, Dinosaur National Monument includes the canyons of the Green and Yampa rivers. Neighboring Artesia, Colorado, has changed its name to Dinosaur and designated its streets with names like Stegosaurus Freeway and Brontosaurus Boulevard. At the quarry, excavation continues, but most bones remain in place in Dinosaur Ledge, enclosed by a visitor center.

Nearby, the Green River flows from the maw of Split Mountain, into the Uinta Basin, where the river slows. The Spanish friars Dominguez and Escalante found a crossing in 1776, on their way west to search for an overland route from Sante Fe to the Pacific Coast. They were the first Europeans to explore deep into Canyon Country and although they did not reach California, they did return home safely, and the map of their travels influenced exploration for decades. Many others followed them through the Uinta Basin, for downstream the Green disappears into cliffs, winding its way through Desolation and Gray canyons.

* * *

By the 1880s, the Frontier was fading fast, but frontier conflict continued as pioneers moved on to cattle-raising once they used up farmland.

Outlaws who started rustling needed a hideout to consolidate their herd before moving it on for sale. They chose an isolated rim above the Green River near its confluence with the Colorado. Box canyons and narrow mesas surrounded them and protected the hideout from surprise approach.

The hideout had been known as Robber's Roost for over fifteen years when Butch Cassidy and his partners rode in after the Castle Gate bank robbery in 1897.

Cassidy and other outlaws rode the Green River between Robber's Roost (above the Maze in Canyonlands) and Brown's hole, Colorado (Dinosaur National Monument). He knew every rancher along the way and attributed his success in evading capture to a single gift: "friends." Jim Mcpherson, who homesteaded at Florence Creek Ranch in Desolation Canyon in 1890, once remarked, "the outlaws were generally a lot nicer folks than the posse chasing 'em."

In 1902, Butch and the Sundance Kid escaped to South America just ahead of Pinkerton detectives. The Sundance Kid died in Bolivia; his lady, Etta Place, became the wife of a government official in Paraquay. Some think Butch Cassidy escaped to Spokane, Washington, to become William T. Phillips, a respectable businessman who died in 1937.

Pearl Baker helped track down much of the story. She grew up at Robber's Roost Ranch, where her father, Joe Biddlecome, took over the range in 1909 after the outlaws moved on. Impassioned by a decade of running the Roost herd herself in the 1930s, she says:

I resent that a dude from Boston—book-trained rather than range-trained—thinks he has as much right to this land as I do, when I build trails, dig out waterholes, move cattle around to protect the range, and treat it as a precious heritage and trust. I resent the fact that all cattlemen are represented as greedy opportunists who rape the range to graze just one more cow. . . . There is something about this country that is deeper than just being here. There is a spiritual quality about it too, that is as deep as life itself.

Like environmentalists, those "dudes from Boston," Pearl Baker is saddened by the drowning of Glen Canyon: "I cried my eyes out over Lake Powell. . . . So much has been lost that can never be regained. Never."

The trouble is this: while we set aside national parks and wilderness areas, we develop this region economically. The canyons and mesas endure a never-ending series of threats to their integrity. They have been used, or are proposed for use, as sites for dams, open-pit coal mines, oil fields, power plants, uranium mines, and nuclear waste dumps. Roads and powerlines crisscross the Colorado Plateau in ever-denser networks. Somewhere between the distant poles of opinion, there must lie balance, a reasonable compromise.

Clifford Duncan speaks of the Ute way:

Land is like a shrine. If you change it, you are competing with the Creator of the world. The Indian way is to follow but don't get ahead. So no one has the right to move the rivers. No one has a right to make dams.

FROM THE ZENITH

As John Wesley Powell and his men floated between Cataract and Glen canyons on the Colorado River in 1869, the last unnamed mountain range in the United States appeared down-canyon. Fred Dellenbaugh described it on the second Powell expedition in 1871:

We could see through to the end of the canyon. . . . The world seemed suddenly to open out before us, and in the middle of it, clear and strong against a sky of azure, accented by the daylight moon, stood the Unknown Mountains . . . in their untrodden mystery.

Powell named these five isolated volcanic peaks the Henry Mountains. The La Sals, Abajos, Ute Mountain, the Carrizos, the Navajo Mountain all surround the Henrys in a great semicircle across the Four Corners.

These mountains and the highest of the plateaus stand at the zenith of Canyon Country. They tether us to the earth and define the horizon. Indian people call the mountains sacred and bound their world with them.

The Henrys remain both the best and least known of these mountains. To most, they are unknown, but to geologists all over the world they are a "classic field area," the defining example of a catagory of mountains called *laccoliths*.

Beneath laccolith mountains, molten rock rises toward the earth's surface but does not errupt or reach a vent. Rising in ponds below ground—*laccolith* means "rock pond"—the lava domes the rocks above, creating mountains. In the Henrys, the La Sals, and the Abajos, erosion has stripped away most of the sedimentary formations, exposing the central core of dark volcanic rock. The unmistakable blue dome of Navajo Mountain seems to be a laccolith still shielded by a bubble of sandstone.

W. H. Holmes, working with the Wheeler Survey in 1874 and 1875, first recognized the Henrys as laccoliths. But it was Powell's associate, Grove Karl Gilbert, who mapped them in detail and worked out their geology. More than sixty years later, Charles B. Hunt expanded on Gilbert's work using the techniques of a new generation of U. S. Geological Survey scientists. In 1936, when Hunt was working on the Henrys' two smallest peaks, the Little Rockies, his packer needed six days to take the horses back to the road head at Trachyte Ranch, maneuver a truck to Green River for supplies, and return to camp. Charlie Hunt remembers those days:

In the 1930s the area still was frontier—a long distance from railroads, paved roads, telephones, stores, or medical services. . . . We didn't have air photos; we didn't have topographic maps. . . . All I had was a copy of the 1875 map made by the Powell Survey and Gilbert's field notebooks. . . .

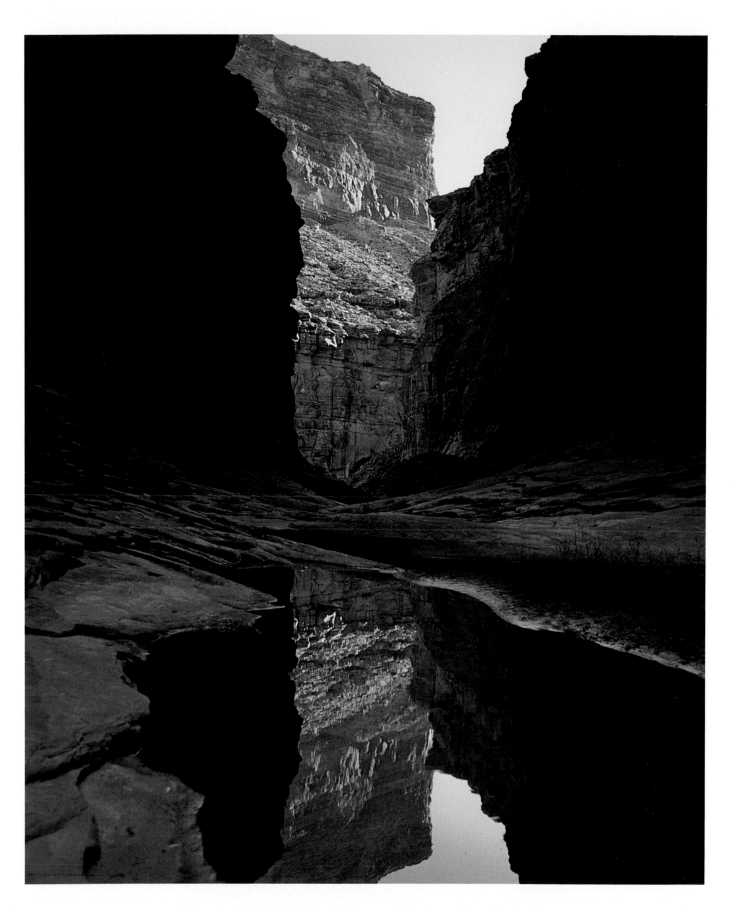

The triumph of the Colorado River and its many tributaries is the Grand Canyon, the most complex and intricate system of canyons, gorges, and ravines in the world. This spectacular network extends from Lees Ferry, near the northern border of Arizona, to the Grand Wash Cliffs near the Nevada line, a distance of 279 miles.

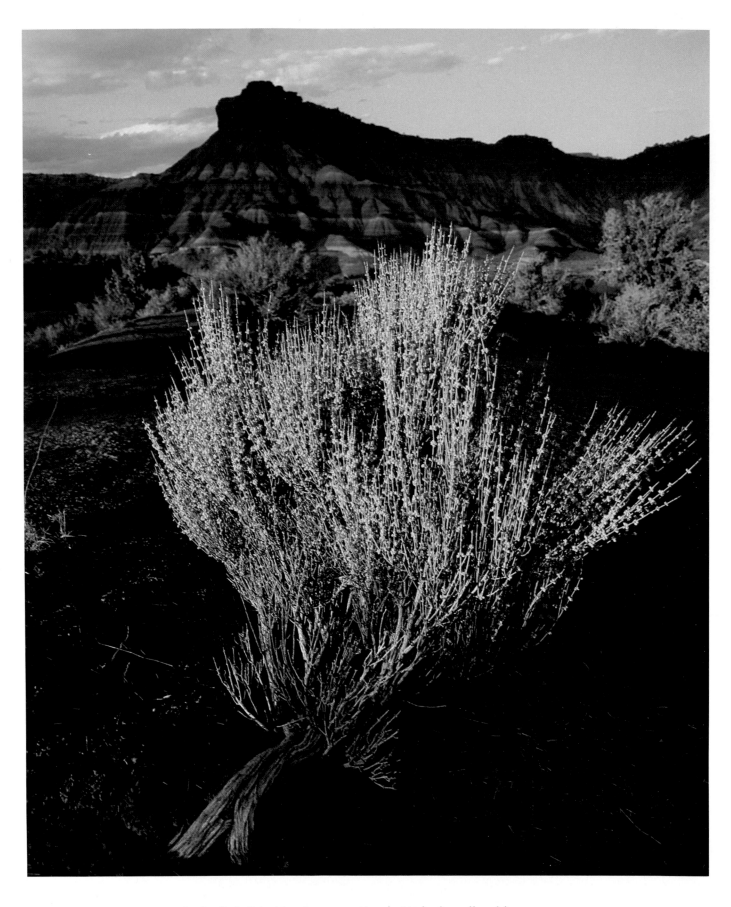

In the Paria Primitive Area near Kanab, Utah, the yellow blossoms of Mormon tea brighten a desert landscape. Before its use as a beverage by early Mormons, various southwest Indian tribes employed the plant for medicinal purposes.

In Canyon Country, volcanic rocks often mean high elevation. Mount Peale in the laccolithic La Sals reaches 12,721 feet, the highest point on the Colorado Plateau. Their flat summits glaciated during the Pleistocene epoch a few tens of thousands of years ago. Erosion-resistant basalt peaks, many standing eleven thousand feet high, cap western Utah's High Plateaus. At the high rims of these planed-off mountains, in the Wasatch Formation, magnificent amphitheaters have been sculpted, as in Bryce Canyon and Cedar Breaks.

The Paiute Indians, masters at harvesting the land, once lived here. Their diet reads like a checklist of the region's plants and animals.

The Colorado Plateau begins at the western foot of the High Plateaus, at St. George, Cedar City, and Richfield, Utah. At the eastern edges of the High Plateaus on the rim of the Aquarius, along the Boulder Mountain Road above Capitol Reef, you look out over slickrock—a desert of stone, red and golden and desert-varnished. From the Paunsaugunt Plateau, you see Bryce Canyon, the zenith of Canyon Country.

The Paiute say Coyote found the Legend People misbehaving in this place and turned them into rocks, creating *Unka-timpe-wa-wince-pock-ich,* or "red rock standing like men in a bowl-shaped canyon." More recent residents named the place for Mormon pioneer Ebenezer Bryce.

The Pollock family of Tropic helped Ebenezer run his cattle. They fenced his cattle below Sunset Point. The current scion of the Pollocks is Herman, who believes in the divine ordination of national parks in southern Utah:

These national parks have a divine purpose. They are not here by chance; they were foreordained. They were found by my own people, by the Latter-day Saints who came to Utah to find Zion. . . . They are fulfilling a destiny—to remove the animosity of the world coming here to see these splendors.

Pollock argues that the scenery of Canyon Country all was created by a three-hour earthquake, a "colossal cataclysm," in 34 A.D. Although geologists might disagree with Pollock about some of these landscapes, they do agree about others. The Canyon Country has seen some cataclysms.

For instance, although a volcano eroded to its central throat becomes a smaller mountain, it remains a mountain: Agathla in Monument Valley rises more than a thousand feet from its base; mighty Ship Rock in northwestern New Mexico rises some seventeen hundred feet above the grasslands.

The Colorado Plateau averages five thousand feet above sea level, and piñon pine and juniper cover its intermediate-elevation mesas. Below lies drier country: desert grasslands and shrublands, where a single clump of wildflowers is a major find—a garden in itself. These arid places may catch only five inches of moisture yearly, but they do not cover enough continuous land to be an official desert.

The tops of the High Plateaus nourish lovely stands of aspen and lush wildflower meadows. These subalpine forests are the wettest places in Canyon Country. Much of their annual forty inches of moisture comes as snow, and the growing season may be only ten weeks in late summer.

Within these forests grow sacred medicines that are used by the Indian peoples. "These herbs are gifts from the Holy People . . ." says Steve Darden of the Navajo tradition. "In our medicine bundles we have earth, plants, and tobacco from each of our four sacred mountains."

Each mountain rising from the vast level surface of the Colorado Plateau focuses attention. We may understand much of their biology and geology, but in their height, grace, and power, these are still unknown mountains.

As Steve Darden says: "The Holy People live in the mountains. There's life up there. That's why it's sacred."

FROM THE NADIR

Voices from throughout Canyon Country come together deep in the Grand Canyon of the Colorado River. Except for the Virgin River, which joins the Colorado below the Canyon, and the Sevier, which flows into the Great Basin, every arroyo, stream, and river on the Colorado Plateau leads into the nadir, into what naturalist John Borroughs called "the divine abyss."

In 1869, John Wesley Powell was looking for blank places on maps where he could make a name for himself. He found them along the Colorado. Powell started his river exploits in Wyoming, on the Green, and explored Dinosaur, Canyonlands, and Glen Canyon. But these were preliminaries. His name is forever linked to the Grand Canyon.

Powell's intelligence equalled his physical energy. When he started hauling students from Illinois Normal University to the West for field trips in 1867, he was advancing his own informal scientific training as much as theirs. Summer wanderings by students still could pass muster as real explorations, and to Powell's delight, "firsts" filled their trips.

Two years later, in 1869, he made his first passage through the canyons of the Colorado, and became the first to document the innermost canyon world. Trappers, prospectors, and military expeditions had seen parts of it before him, but Powell connected the river to the rest of mapped reality.

On the seventieth day out from Green River, Wyoming, he and his men camped at the confluence of the Colorado and San Juan rivers. Powell wrote:

. . . past these towering monuments, past these mounded billows of orange sandstone, past these oak-set glens, past these fern-decked alcoves, past these mural caves, we glide hour after hour, stopping now and then, as our attention is arrested by some new wonder. . . .

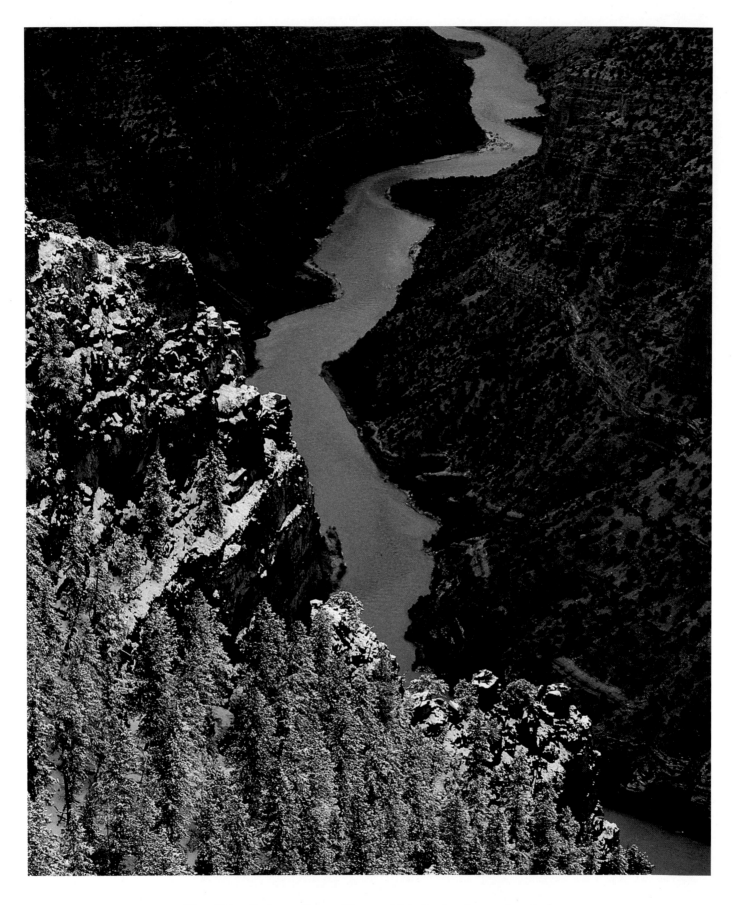

The 730-mile-long Green River, which begins in west-central Wyoming, winds its way through the center of Dinosaur National Monument before converging with the Colorado River. Dinosaur lies in both northeastern Utah and northwestern Colorado and marks the beginning of the Colorado Plateau.

They needed the rest. Another month remained of their voyage, and after just four days more in Glen Canyon, they reached the mouth of the Paria and saw below them the river cutting into the limestone that "bodes toil and danger." They entered Marble Gorge, and the Grand Canyon swallowed them, spitting them out 279 miles later, minus three men. The three left the expedition in despair over unrelenting rapids and dwindling rations, only to be killed by Paiutes.

Powell and his men ran the river twice, returning in 1871 and going as far as Kanab Creek, halfway through Grand Canyon. Not for many years would Colorado river-runners learn enough to avoid the unnerving rides, the toilsome lining and portaging, and the spills that ruined food and equipment.

John Wesley Powell turned his curiosity loose in Canyon Country for a few years, spun out a series of bold geologic ideas, then moved on to Washington, D.C., where he helped establish the United States Geological Survey. He left behind a group of remarkable associates who filled out his ideas.

One of them, Clarence Dutton, published his masterwork, *Tertiary History of the Grand Canyon District* in 1882, barely ten years after Powell's river expeditions. Dutton made the Grand Canyon his own. He called it: "the sublimest thing on earth. It is so . . . by virtue of the whole—its ensemble."

Both in his science and his prose, Dutton succeeded as well as anyone in understanding this complex landscape. He warned others who would try to fathom the Grand Canyon:

A perpetual glamour envelops the landscape. Things are not what they seem. . . . As the mind strives to realize [the Canyon's] proportions, its spirit is broken and its imagination is completely crushed.

Some people dared to make the Grand Canyon the focus of their lives. Others tried to live there as they would anywhere—but the Canyon always fooled them, casting what Dutton called its "spell of enchantment," a "troubled sense of immensity." The immensity always is there. It is a presence, an abstract concept elsewhere that here you can see. Some never cease to find it "troubling." For others, there is something companionable about such vastness.

Adventurers have been drawn to the Colorado River in the Grand Canyon for more than a century since Powell. Ellsworth and Emery Kolb made motion pictures of their 1911 trip and showed these movies at their little studio perched on the South Rim for the next sixty years. In 1937, Buzz Holmstrom became the first person to run the Canyon solo and tried hard to hold true to its lessons of humility:

I have already had my reward, in the doing of the things, the stars, cliffs and canyons, the roar of the rapids, the moon, the uncertainty and worry, the relief . . .

Nowhere is the contrast between the Colorado and the arid canyon walls it carves through more vivid than in Grand Canyon. A river trip overwhelms you with the difference between wet and dry. And nowhere does the scale of the river and the canyons come as clear as it does when you "swim" a small rapid, bobbing through the waves to get the feel of your life vest in case your raft flips in Horn Creek or Sockdolager Rapids and you have to swim. Surrounded by the cold water of the river, you feel small and fragile, but joyfully alive.

Along the river, side canyons lead up to hidden paradises: alcoves with still pools and exotic touches of fern and monkeyflower. At Havasu Creek, the water seems extravagant, its milky blue-green (colored by travertine) tumbling down past the home of the Havasupai Indians, over cascades and waterfalls, through tangles of wild grape, to mingle with the Colorado—a barbaric stream by comparison.

In 1948, fewer than one hundred people had run the Colorado River through the Grand Canyon. By 1954, the total had reached two hundred. But in the 1950s and 1960s, commercial river-running companies flourished. In 1972, more than sixteen thousand people ran the river in one year, and it became clear that the Colorado had to be managed. Or rather, the *people* had to be managed; the river already was, for the headgates closed at Glen Canyon in 1963, transforming the river world of the Grand Canyon all the way to Lake Mead.

In the 1930s, Glen Canyon was the centerpiece of a mammoth proposed park. Escalante National Park, named after the Spanish Franciscan who traversed the Canyon Country in 1776, would have preserved seven thousand square miles of southeastern Utah. During hearings on the proposal, Charlie Hunt testified before Congress as a geologic expert; few other scientists knew the canyons away from the river. He spoke enthusiastically about the park but felt Congress was a little uneasy, even in those days, about its size: "It was too big a piece of country to take out completely from use." Toward the end of the 1930s, other matters took precedence in Washington, D.C., and Escalante National Park died on the desk of the Secretary of the Interior.

Twenty years later, Congress legislated other uses for Glen Canyon. As a result, the Colorado River now disappears in Lake Powell, the reservoir backed up behind Glen Canyon Dam. One hundred eighty miles downstream, the river re-emerges below the dam, controlled not by spring runoff from the Rocky Mountains but by computers programmed to serve power needs in distant cities.

The reservoir filled in 1980. Today the release of water into the Grand Canyon fluctuates drastically between three thousand and thirty thousand cubic feet per second (cfs), although in 1983, Mother Nature took over from the computers and heavy runoff forced releases of one hundred thousand cfs. That year, young river-runners had a taste of the old Colorado—"Big Red."

Steven Carothers, a research biologist for Grand Canyon National Park, has been studying the ecology of the Grand Canyon since the first National Park Service research river trip in 1968. He now works in the canyon surveying fish populations by electrofishing at night, when the fish cannot see his boat approaching. Carothers has run every stretch of the river but Lava Falls and Crystal Rapid in the dark: "At night the whole river becomes the same unknown Powell must have felt. But we just catch glimpses of that uncertainty and fear, because we always know when a rapid will be over. Powell didn't have that luxury."

Today, water releases must be balanced in order to maintain enough flow for river-running, for power generation, for delivery of irrigation and drinking water to the lower Colorado River Basin, for threatened native fish and birds like humpback chub and Bell's vireo, for a trophy trout fishery, for preserving the river's sediment load and camping beaches—and for a hundred other resource needs we can define and a thousand we cannot.

Steve Carothers says:

"Our task is to guess right, to project and to predict, based on what we can see now. It's real dangerous because we don't have the whole story yet; we need another fifty years.

The management Carothers talks about involves hundreds of miles of river—180 miles of Lake Powell, 240 miles of the free-flowing Colorado above Lake Mead in Grand Canyon, and, downstream, a series of reservoirs all the way to the sea. Few people can think in such terms. Even fewer can comprehend the time scale of the Grand Canyon.

The Grand Canyon confounds comprehension. A little more than a century after Powell and Dutton studied it, we still cannot say exactly how old it is or how it formed. The river has flowed in Marble Gorge for thirty million years, according to the evidence in the rocks. But after the Colorado meets the Little Colorado River, it inexplicably turns west and cuts more than six thousand feet deep through the Kaibab Plateau, slicing its way through to some of the most ancient rocks exposed on the continent: 1.7-billion-year-old Vishnu Schist, rock that makes the "old" canyon above seem downright youthful.

Geologists also know the river could not have flowed through the Grand Wash Cliffs where it leaves the western end of Grand Canyon until about six million years ago. So not until then could the Colorado River achieve its present course in Grand Canyon. The Gulf of California did not exist until four or five million years ago, so drainage beyond the Colorado Plateau remains completely mysterious.

We do not yet have a widely accepted story that ties these facts up in a neat package, and this seems appropriate. The Grand Canyon will never be a neat package.

The Hopis understand this. As Hopi artist Micheal Kabotie says, "The Grand Canyon is symbolic of the womb just like the kiva is a symbol for the womb. And when you die, you go back through the Grand Canyon to the underworld." For the Hopi, life has both its beginning and its end in the Grand Canyon.

Steve Carothers talks about his feelings:

Every year now for as long as I can remember, we have run the river in December. That's my favorite time. Nobody else is there. It's incredibly peaceful. And incredibly demanding. . . . It takes that combination of extremes—the physical as well as the intellectual, the entire animal—to put all the pieces together. Everything gets whole. I can't find that world without boundaries anywhere but Grand Canyon.

THE SEVENTH DIRECTION

Somewhere within these six directions lies the center, the heart of Canyon Country.

Edward Abbey mused about this heart of the canyonlands in his book, *Beyond the Wall:*

There was a time when, in my search for essences, I concluded that the canyonland country has no heart. I was wrong. The canyonlands did have a heart, and that heart was Glen Canyon and the golden, flowing Colorado River.

Navajo people define the heart as the seventh direction. Anywhere in Canyon Country, anywhere between their sacred mountains, can be the center. It is wherever we are, right now within the six directions: the point of balance. Steve Darden calls it "a feeling of reassurance."

Navajos celebrate this balance every day in their prayers:

With beauty before me, I walk
With beauty behind me, I walk
With beauty above me, I walk
With beauty below me, I walk

From the East beauty has been restored
From the South beauty has been restored
From the West beauty has been restored
From the North beauty has been restored
From the zenith in the sky beauty has been restored
From the nadir of the earth beauty has been restored
From all around me beauty has been restored.

From the six directions come beauty and harmony, what the Navajo call *hózhó.* Daily restored to us, *hózhó* is alive all around us in this place called Canyon Country.

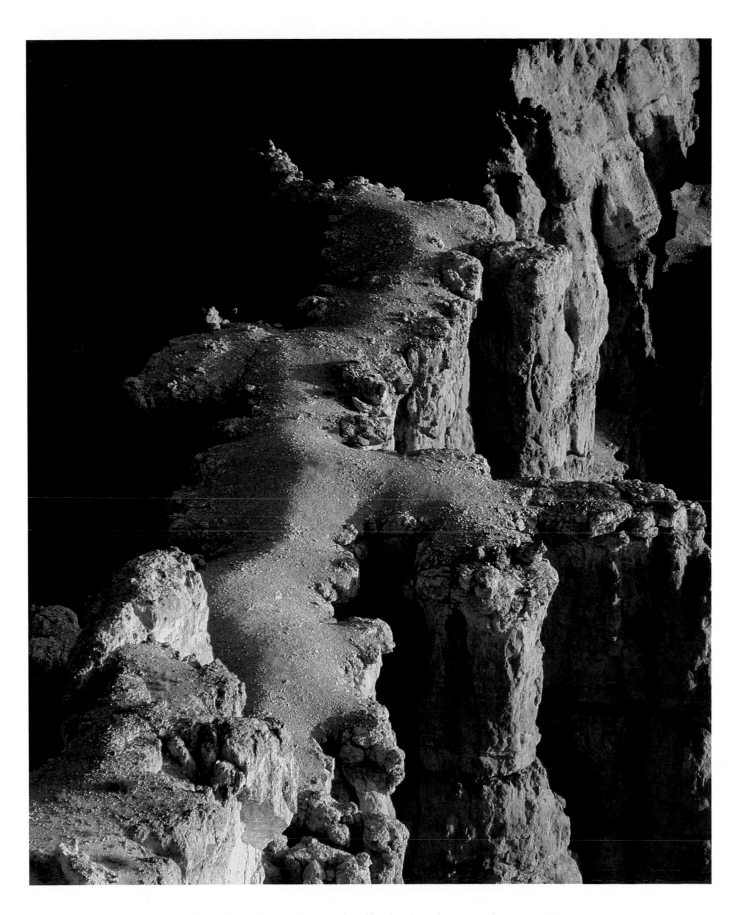

Throughout Bryce Canyon, hard beds of sandstone and cemented gravel provide protective caps for the softer and more easily eroded limestone beneath. Eventually, the limestone dissolves, and the walls and towers collapse.

BRYCE & CEDAR BREAKS

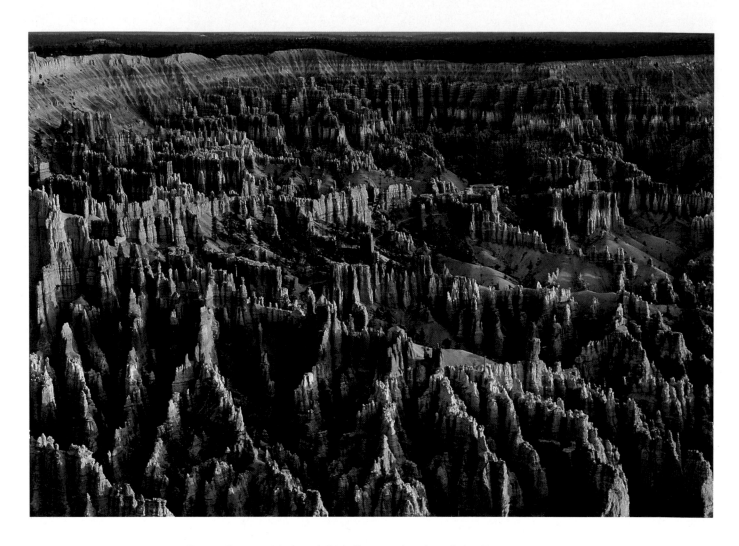

Bryce Canyon National Park lies on the rim of the Paunsaugunt Plateau, one of the High Plateaus of Canyon Country. The Paiute who hunted in Bryce described the rock forms with a word meaning "red rocks standing like men in a bowl-shaped canyon."

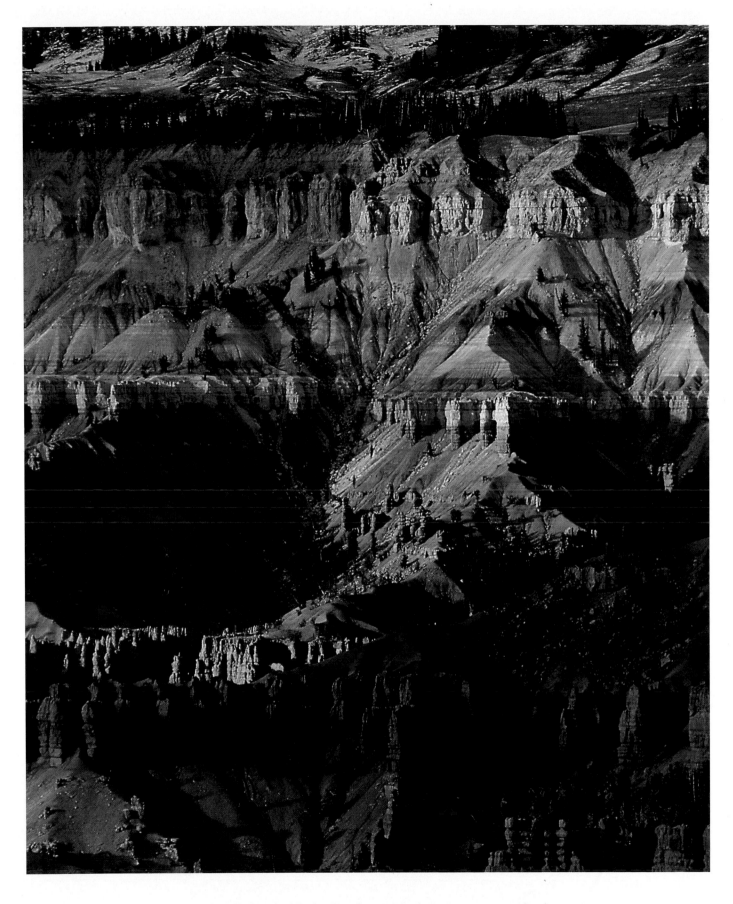

■ *Above:* Nearby Cedar Breaks National Monument cuts back into the Markagunt Plateau, which lies two thousand feet above Bryce. ■ *Overleaf:* The pinks, yellows, mauves, and umbers that illuminate Bryce are derived chiefly from iron and manganese, which reflect the sun's shifting rays.

23

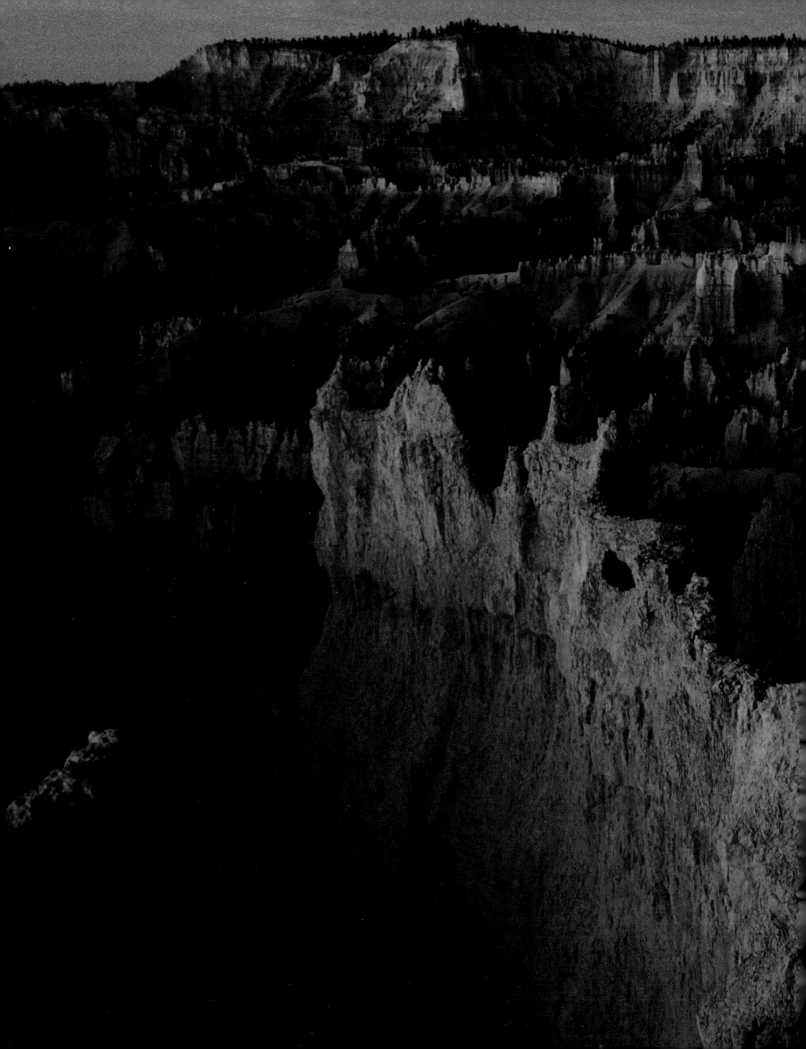

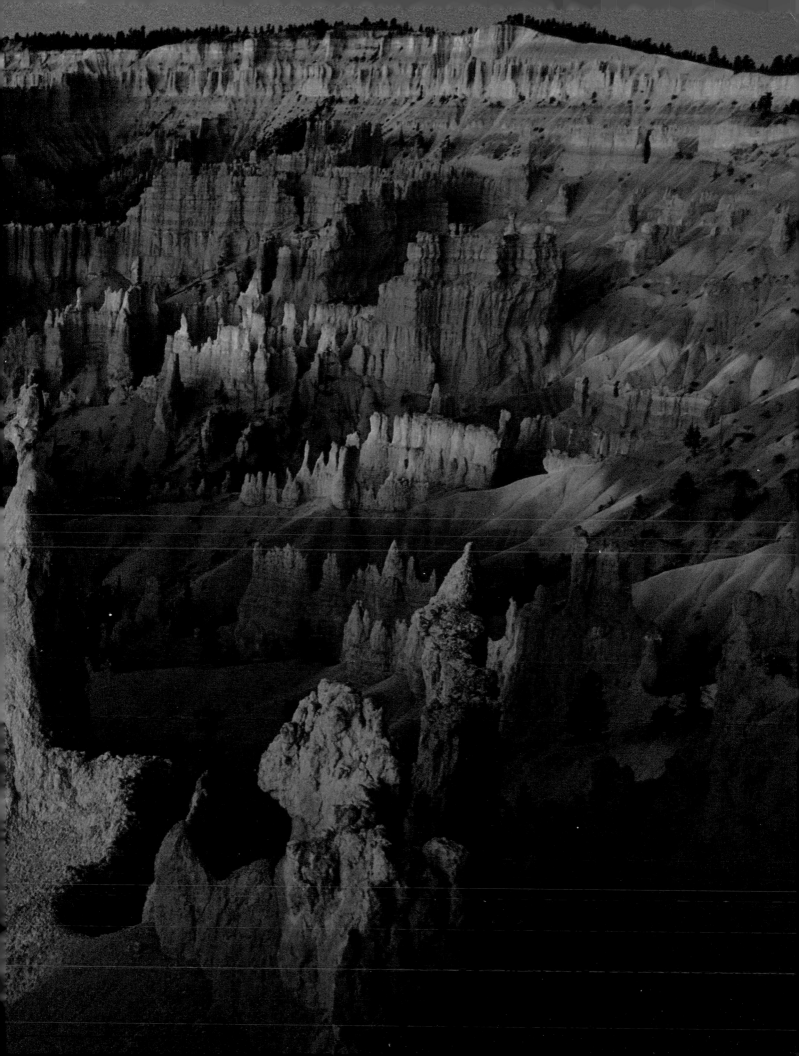

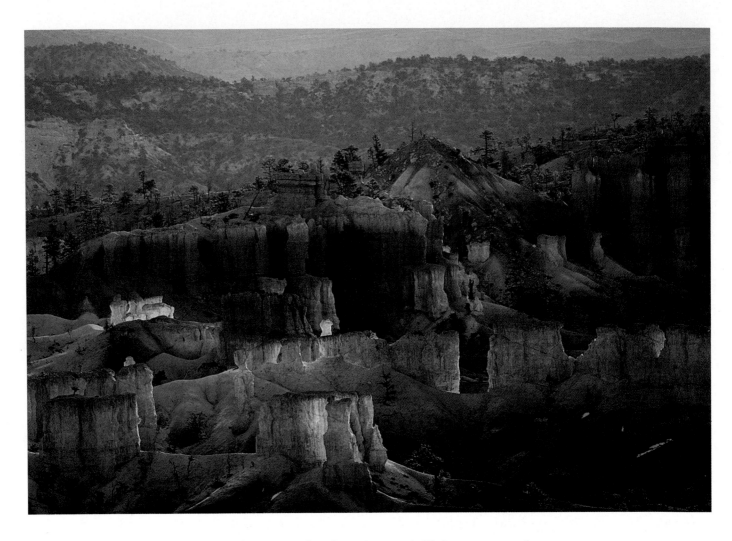

On an early winter's day, the only sounds likely to emanate from Bryce Canyon are the sounds of erosion: the cracking of fissures or the falling of rocks from limestone walls.

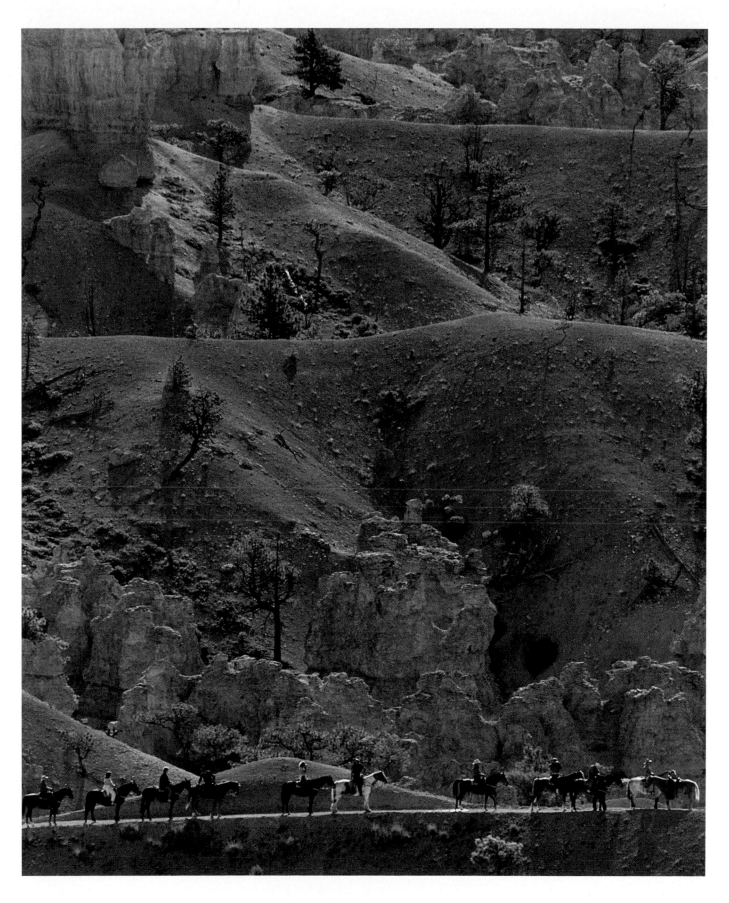

Limestone and siltstone compose the walls and pinnacles of Bryce Canyon. Part of the Wasatch Formation, sixty million years ago these deposits were laid down in the lake that once covered the landscape. Climbing the switchbacks that lead in and out of the canyon is arduous even by horseback.

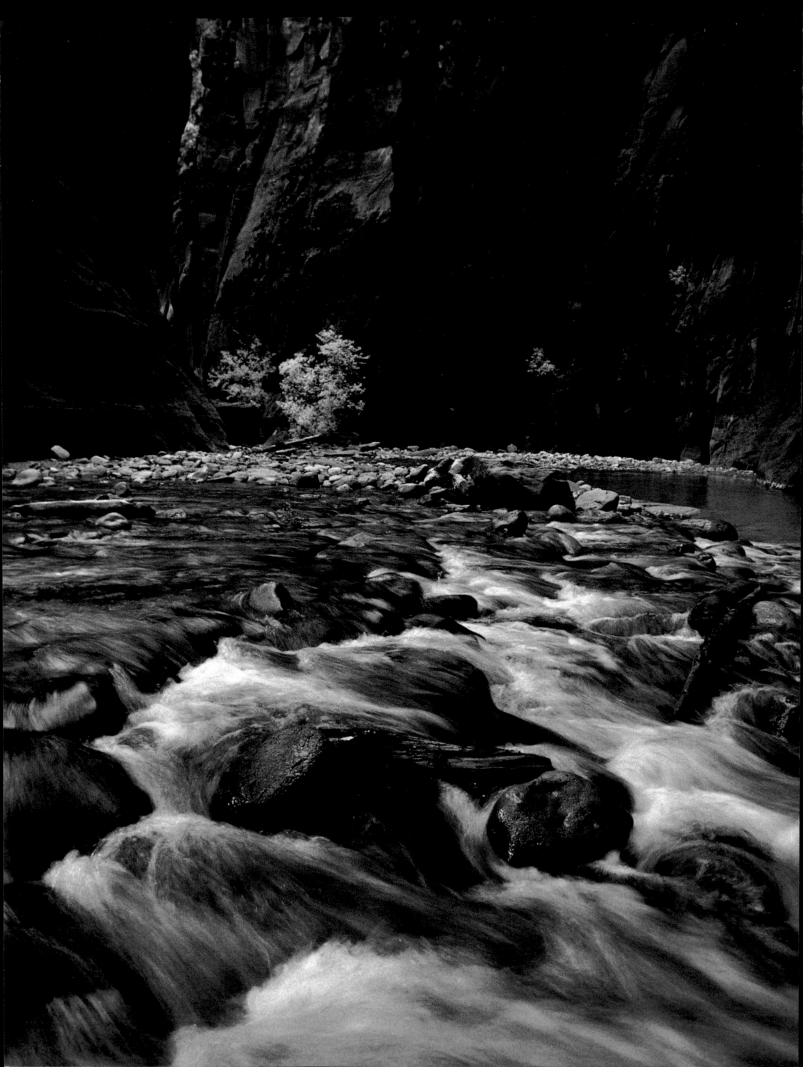

ZION

■ *Left:* The Virgin River Narrows, with canyon walls barely sixteen feet apart in places, drops thirteen miles, from Markagunt Plateau to Zion Canyon. ■ *Above:* Zion's beloved Watchman radiates an orange glow at sunset. ■ *Overleaf:* Unlike California's Yosemite Valley, carved by a glacier, Zion was cut mostly by the Virgin River.

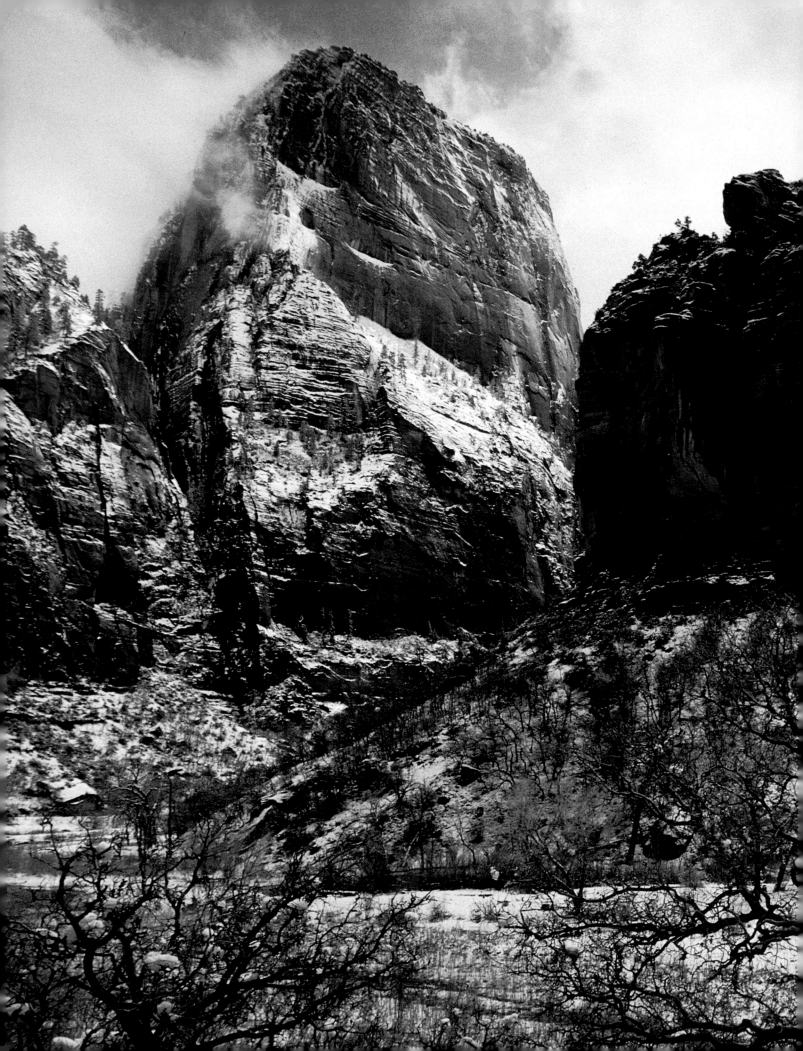

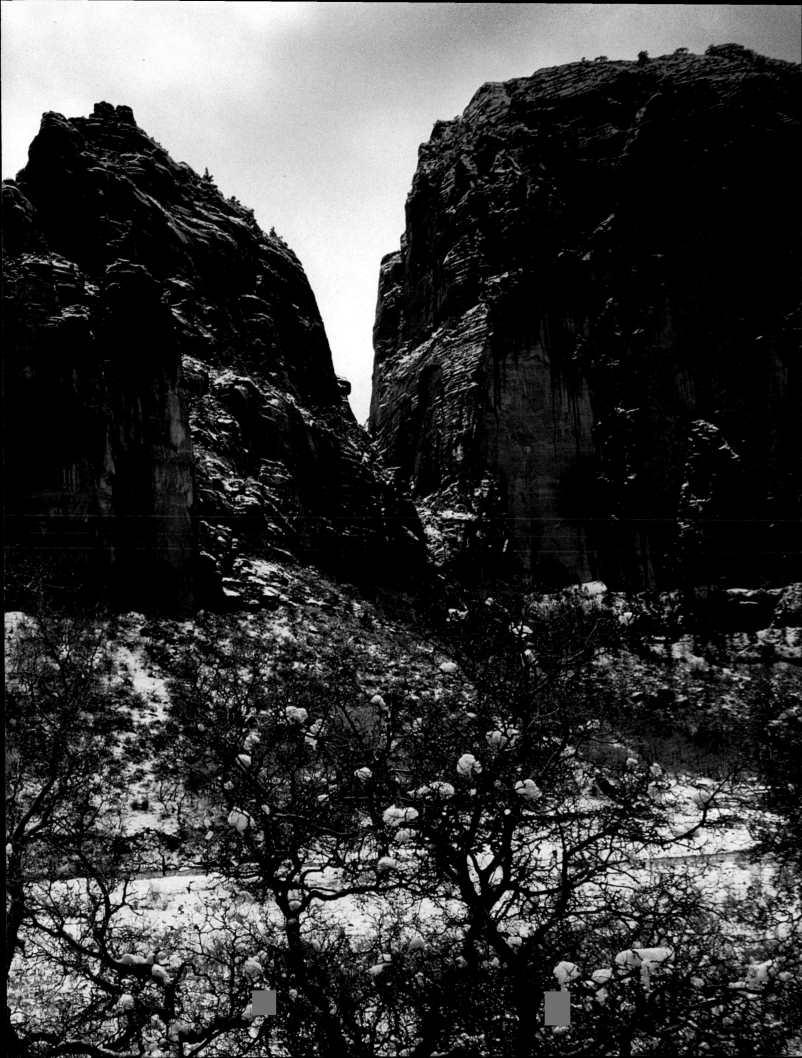

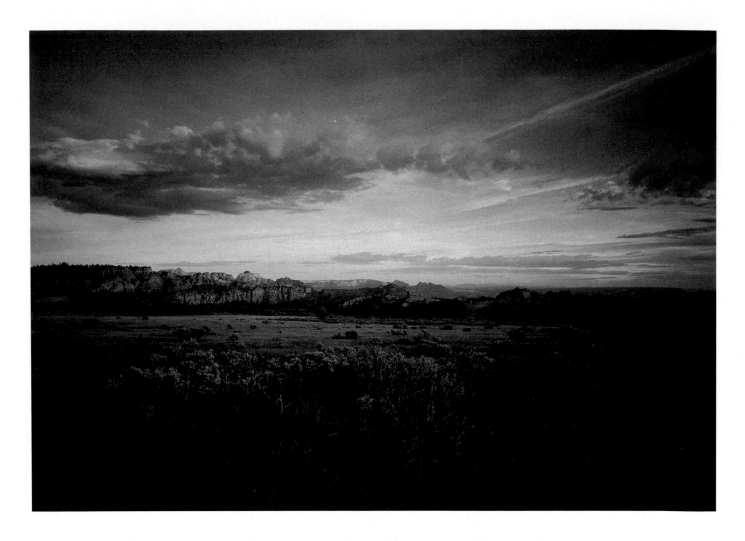

Because of its comparative lack of fame, some call Zion's Kolob region, in the park's northwest, the "hidden showcase of Zion." Within the park's 147,000 acres lie four major plant zones, ranging from desert to forest. They extend from altitudes of less than four thousand to nearly nine thousand feet.

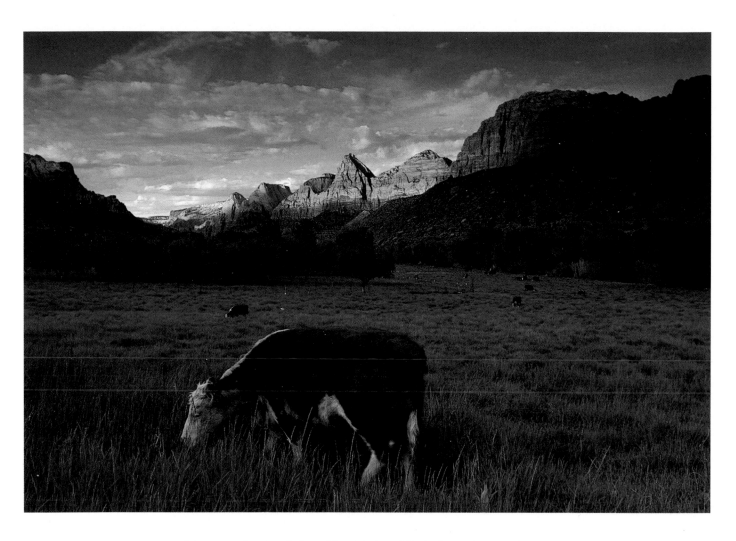

Prime grazing land abuts Zion National Park. From 1861 to 1909, Mormon settlers grazed cattle and sheep on the canyon floor, until President William Taft proclaimed Mukuntuweap, or "straight canyon," a national monument. Barely ten years later, in 1919, Mukuntuweap became Zion National Park.

■ *Above:* Natural reservoirs, potholes filled by spring rains and snowmelt along Zion's eastern border both sustain and create myriad life forms. ■ *Right:* Buried under canyon maple leaves may be eggs of tadpole shrimp, which are laid in water and must wait for water to hatch. The hardiest eggs can survive twenty-five years.

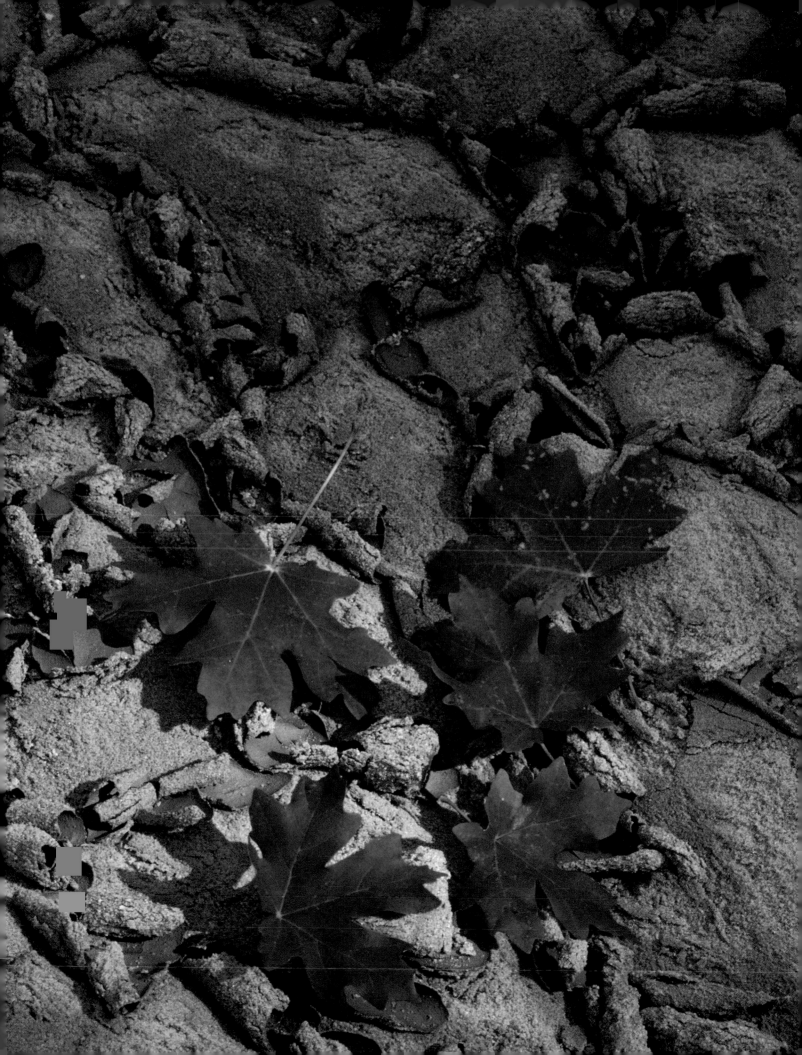

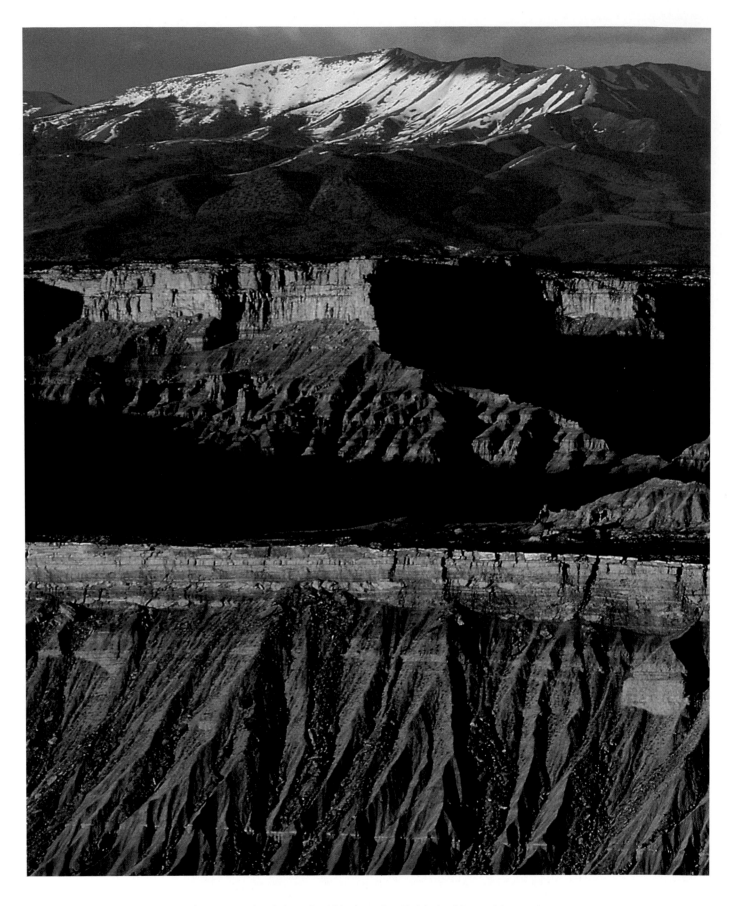

The eastern backdrop for Waterpocket Fold, the Henry Mountains were the last range in the lower forty-eight states to be mapped. Although unknown to most people, the Henrys are well-known by geologists as *laccoliths,* which means "rock pond." Lava domed the rocks above, creating the mountains.

CAPITOL REEF

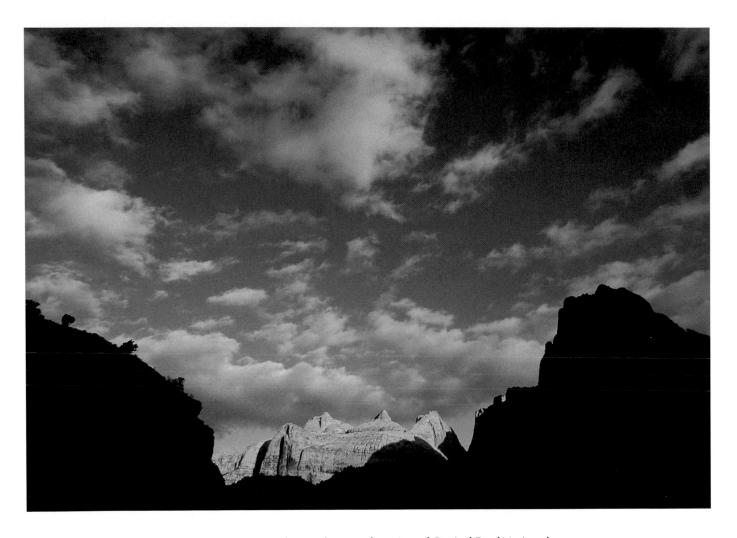

Navajo Dome, in the north-central section of Capitol Reef National Park, evokes a similar dome-shaped structure in Washington, D.C. Such domes gave the park the word "Capitol" in its name.

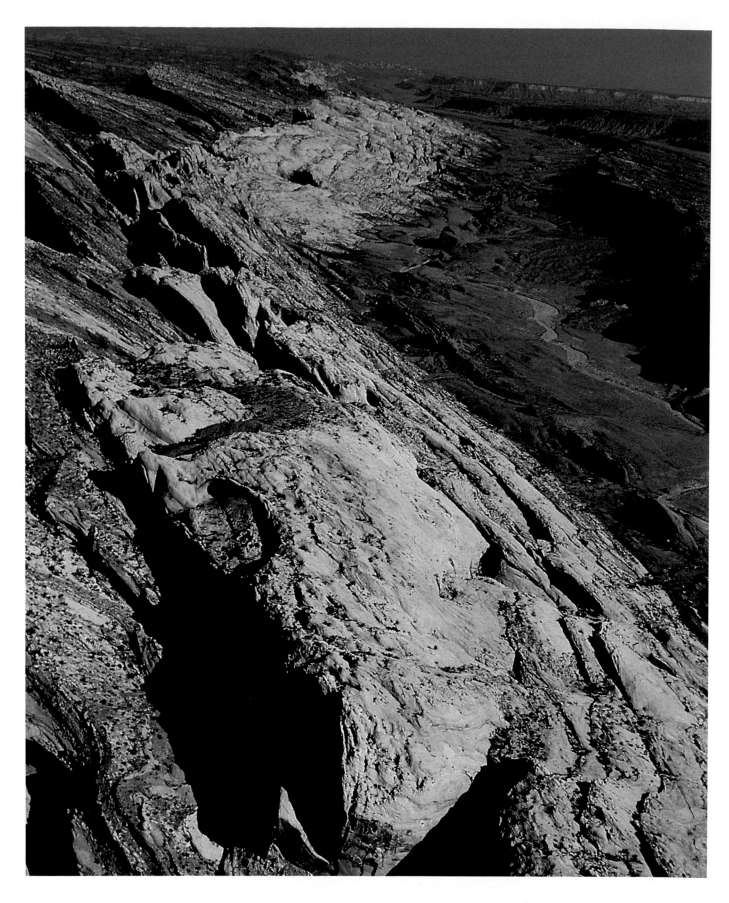

The sinuous, monoclinal Waterpocket Fold results from horizontal
layers of sedimentary rock tilting, then buckling during the long,
slow uplift of the Colorado Plateau some sixty million years ago.

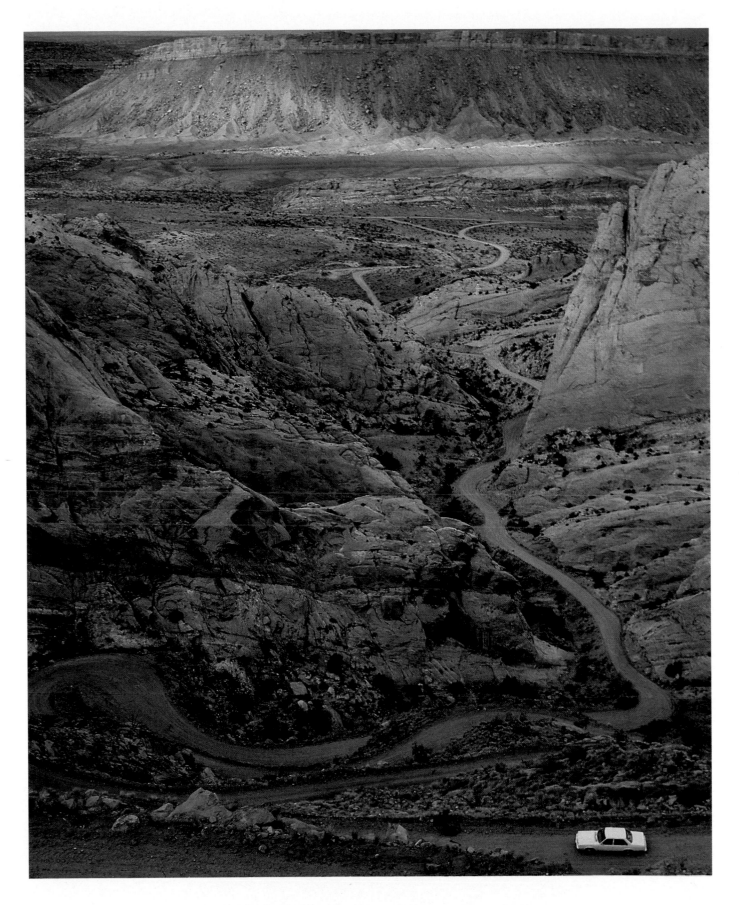

■ *Above:* The only road across the southern Waterpocket Fold, the unpaved Burr Trail, winds down precipitously from the crest.
■ *Overleaf:* A magnificent sandstone escarpment towers above what was originally the Mormon town of Fruita and its orchards, and is now Capitol Reef National Park's main campground.

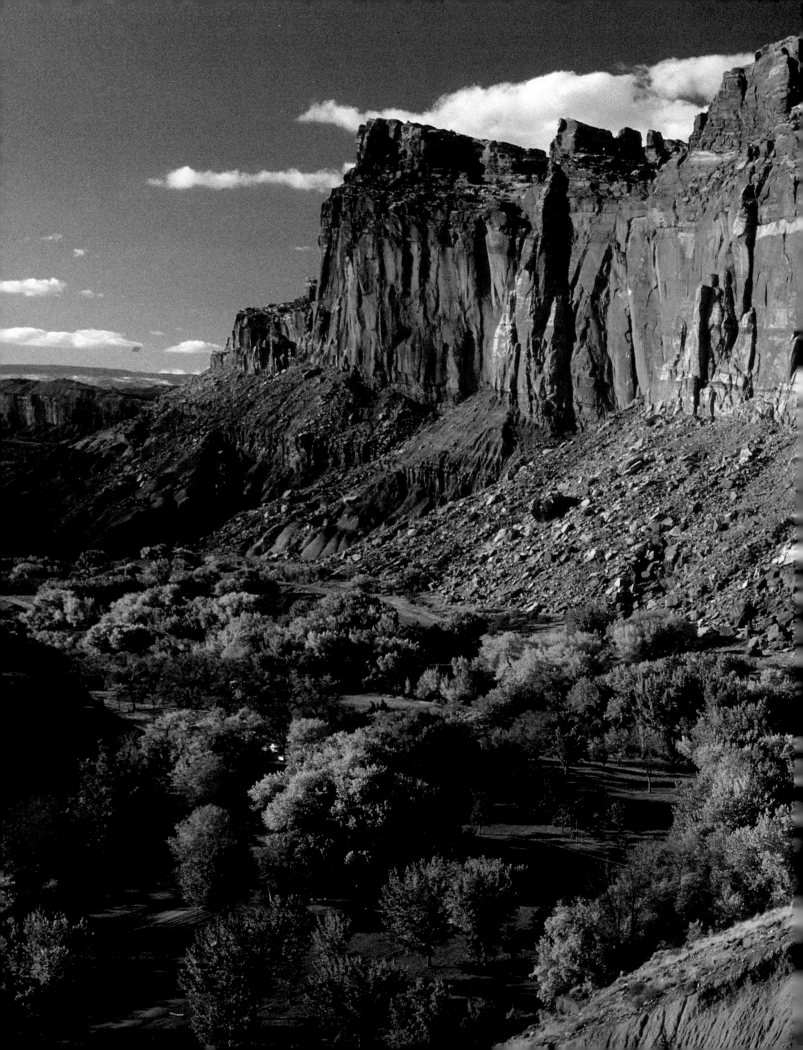

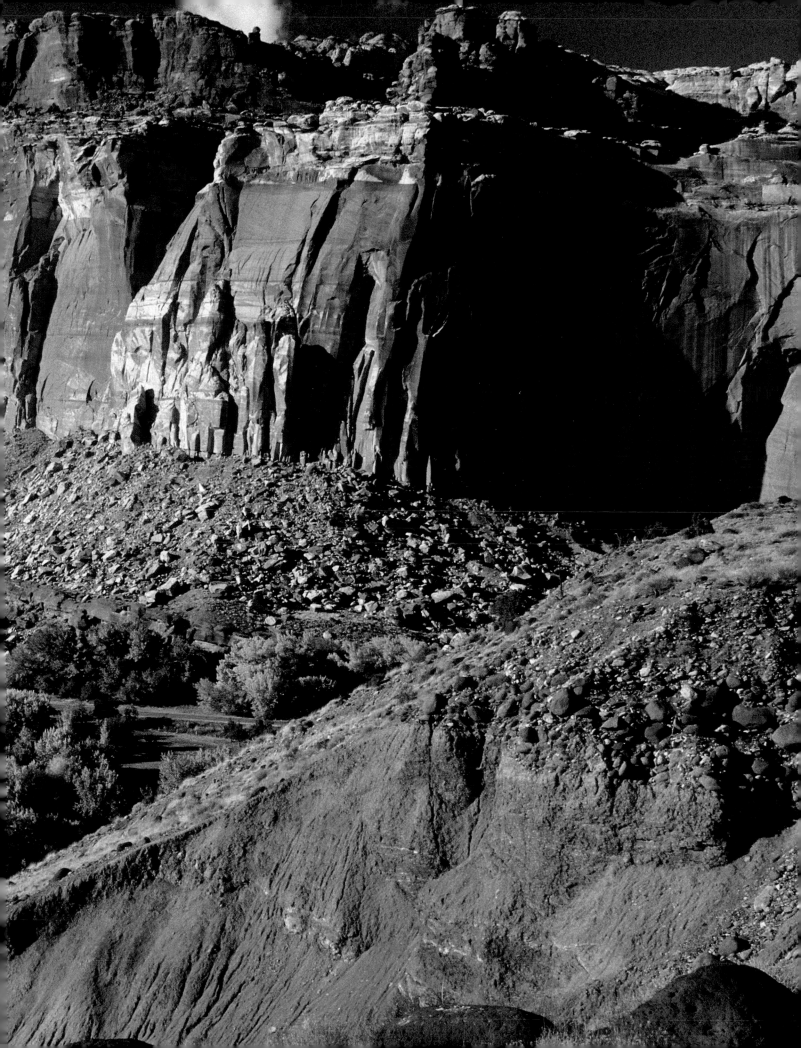

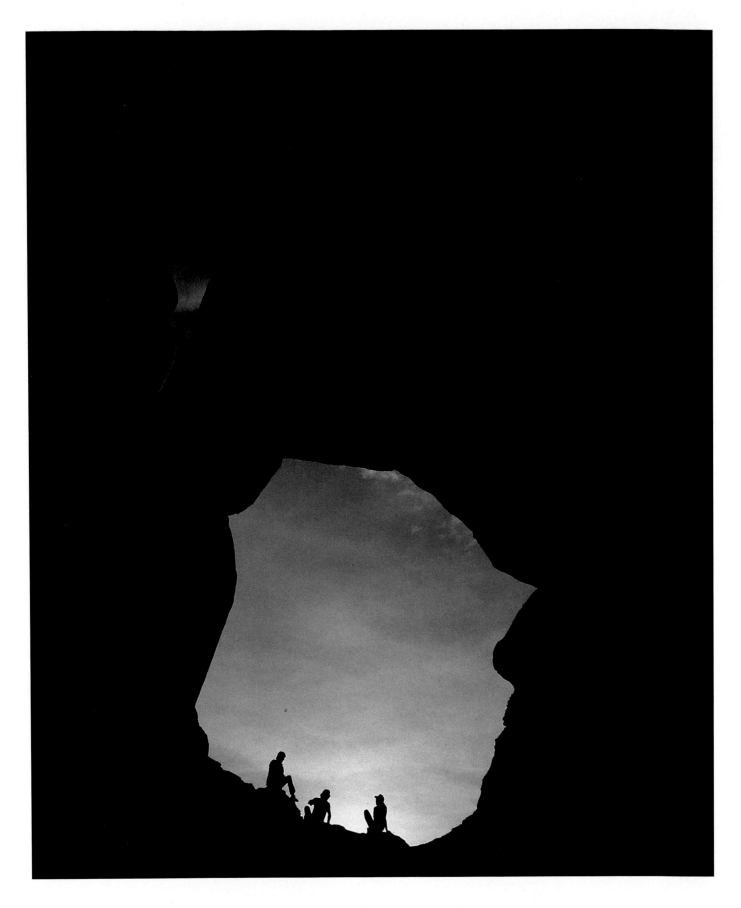

Ensconced in Double-O Arch, hikers relax at twilight. No records list the first white explorers, but rock art indicates Arches was an ancient hunting ground for both Anasazi and Fremont Indians.

ARCHES

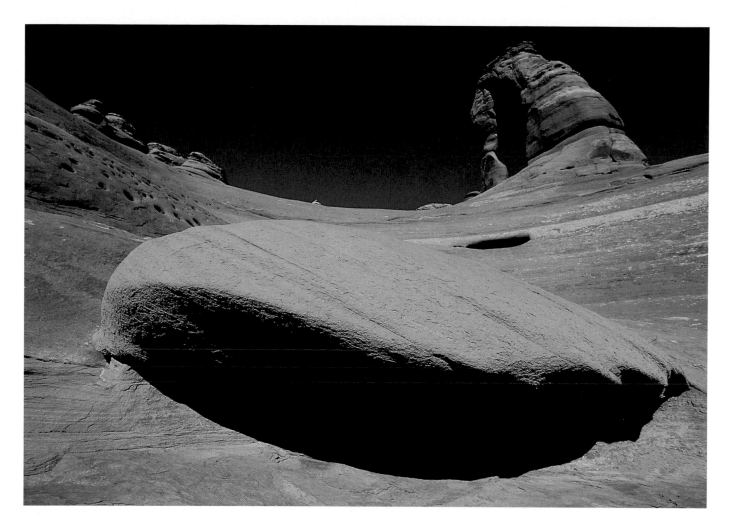

A proud martyr to the elements, Delicate Arch straddles a basin of smooth Entrada Sandstone. Rain, snow, wind, changing temperatures, and gravity constantly wear away its stately structure.

Skyline Arch near the Devil's Garden Campground more than doubled in size in 1940, when a great block of sandstone fell out of its opening. Before that, it was called "Arch-in-the-Making."

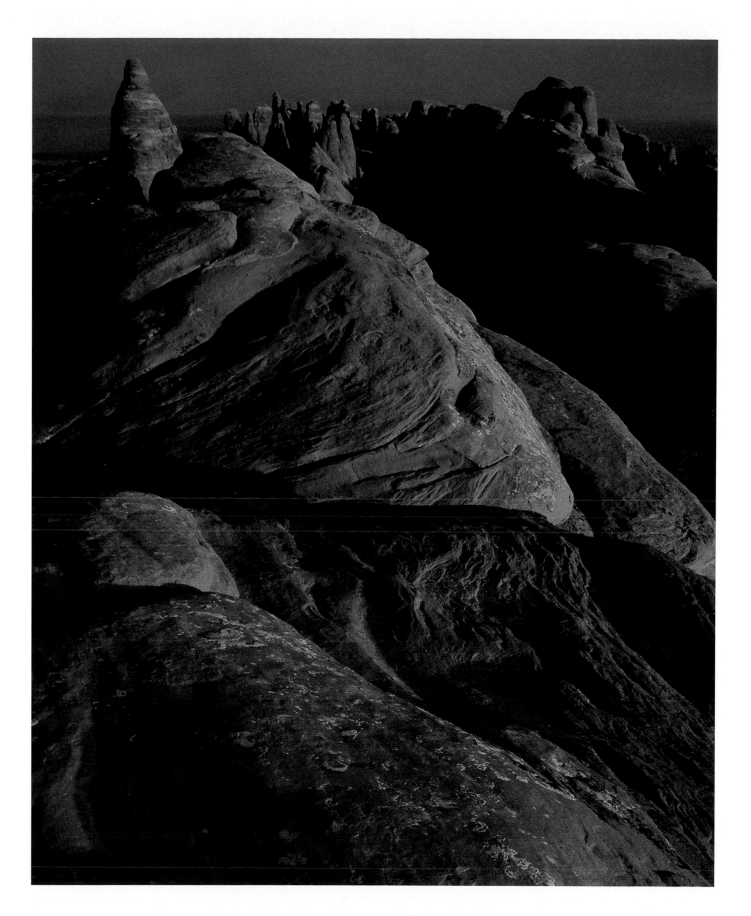

■ *Above:* Salt from a vanished sea underlies Arches National Park. Movement of salt and regional uplift caused fractures in overlying rock. The fractures eroded, fins of rock appeared between them, and recesses in the fins weathered into arches. ■ *Overleaf:* Old by comparison to others, Delicate Arch will one day topple.

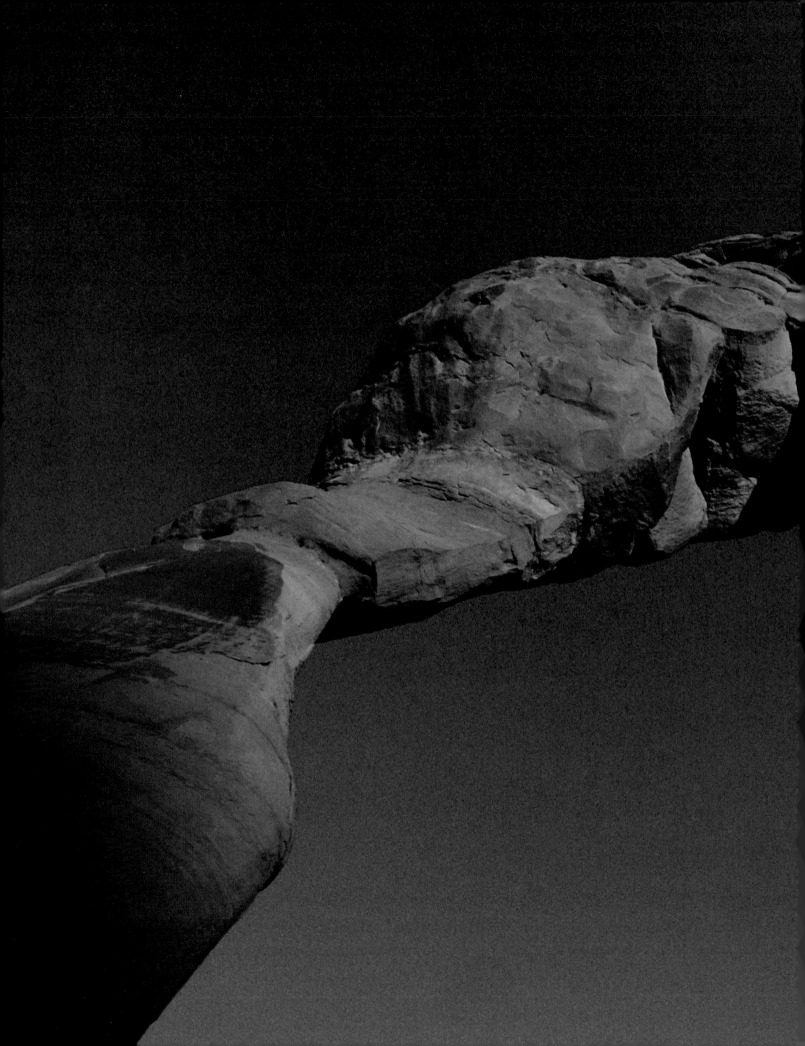

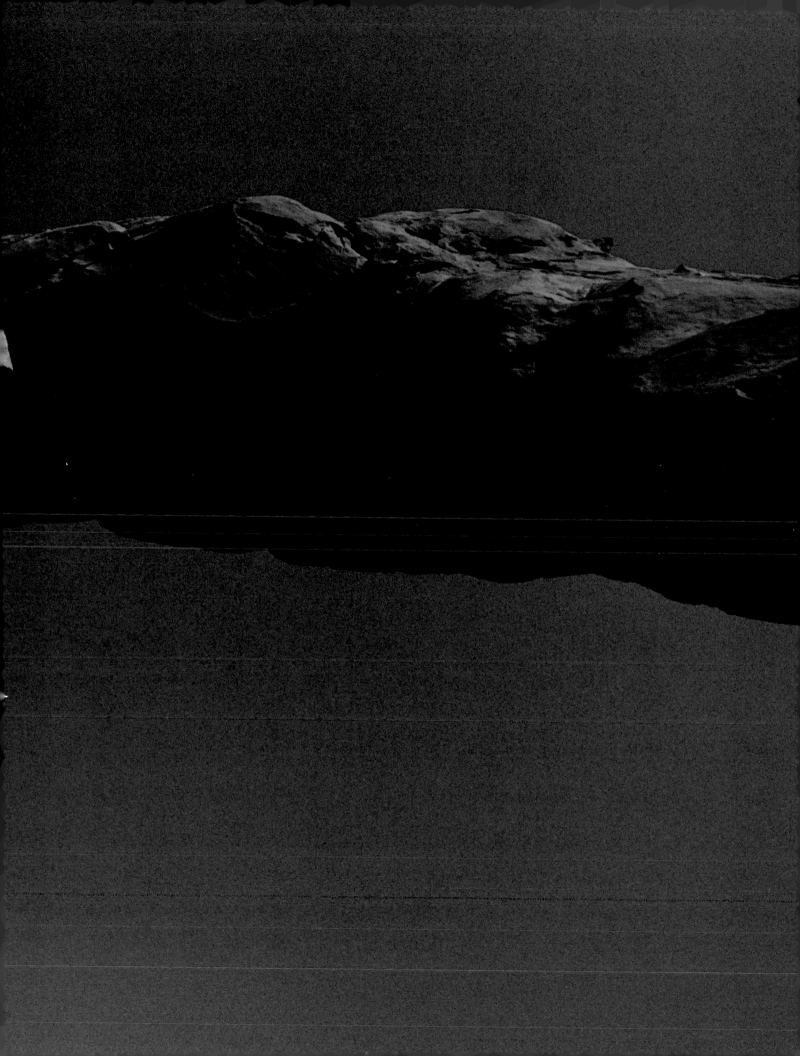

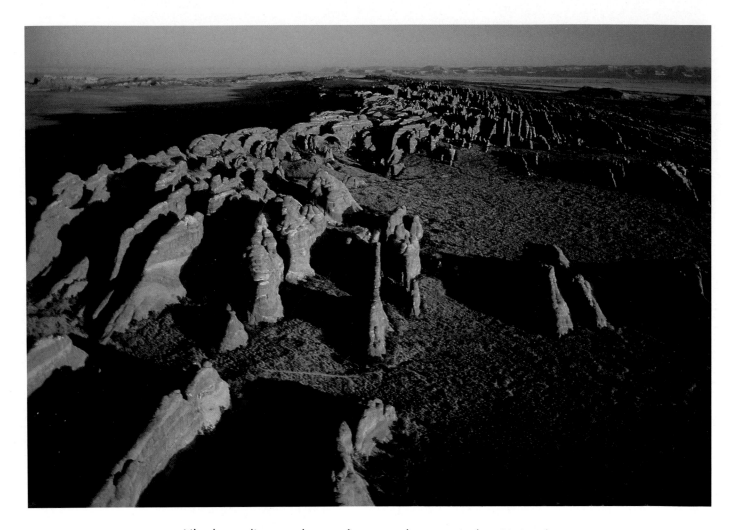

Like huge dinosaur bones, fins sprawl across Arches National Park's northern section, known as Devil's Garden. Ranging in color from dark red to black, desert varnish derives from manganese and iron oxides. These minerals require sufficient precipitation and high evaporation rates to develop into the thick, glossy patina.

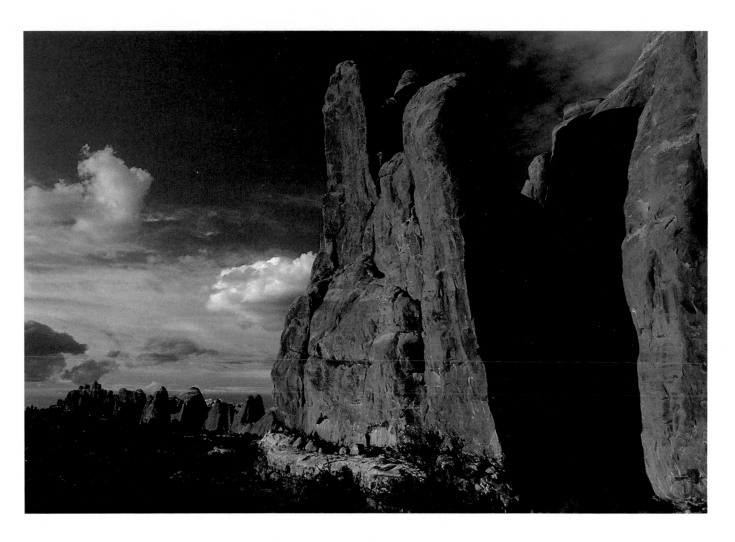

The major sandstone formation that characterizes the walls and fins of Arches National Park is called Entrada and dates from the Jurassic Period some 150 million years ago.

DINOSAUR

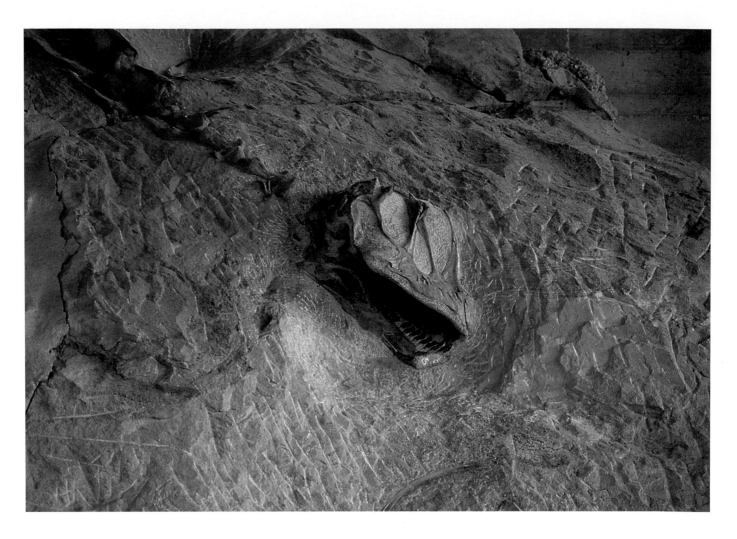

A main attraction at Dinosaur is the quarry-museum. Since 1909, paleontologists have uncovered a remarkable collection of mineralized dinosaur bones, including this skull of a Camarasaurus.

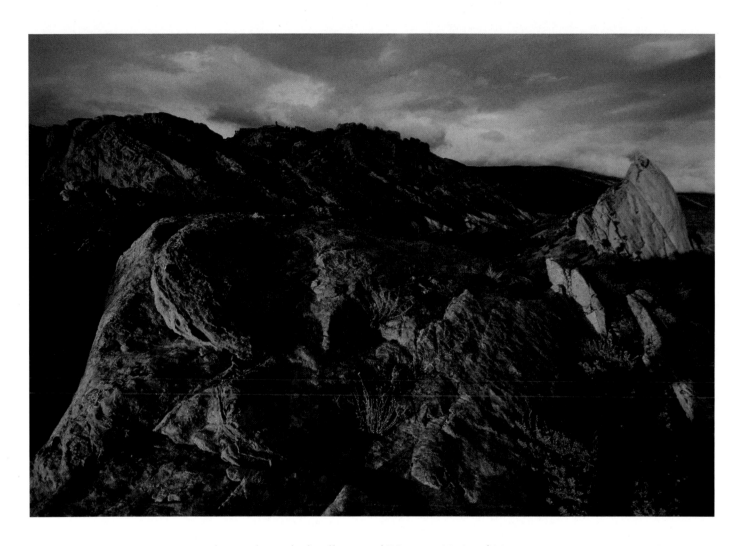

■ *Above:* The rocky knolls around Dinosaur National Monument attest to a time when the Rocky Mountains began to rise. This area was also much affected. The mountain-building squeezed the rock layers from the sides, warping and tilting them. ■ *Overleaf:* Split Mountain rises over a field of grazing cattle.

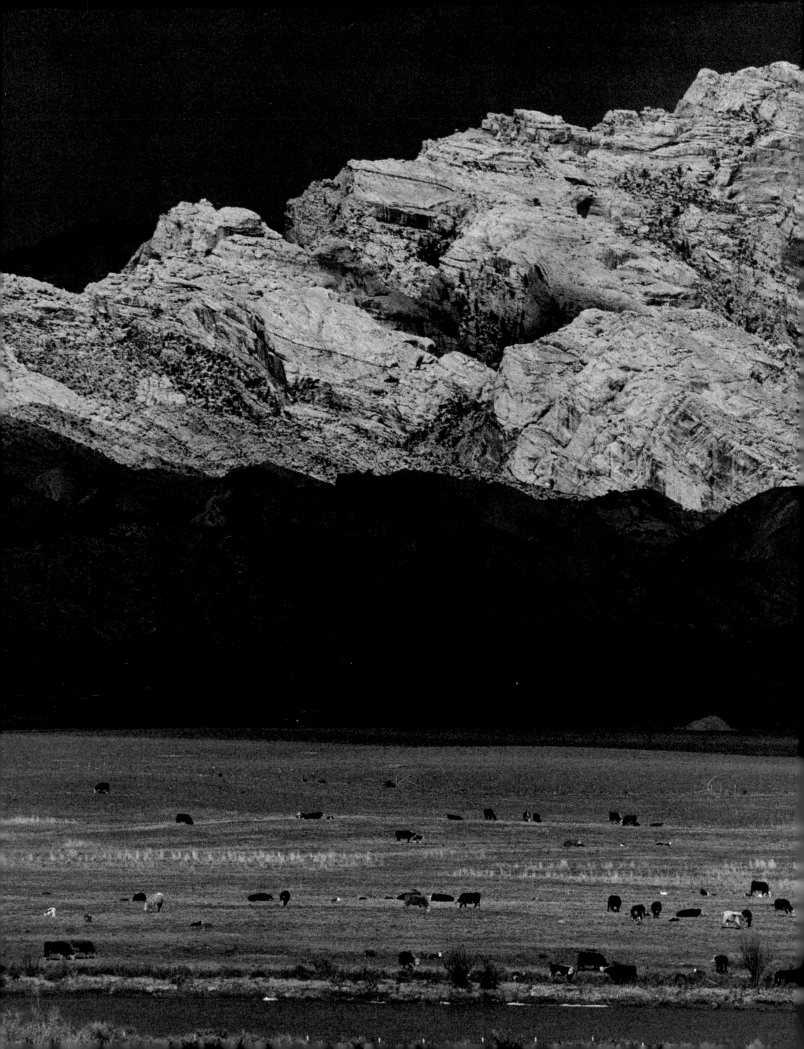

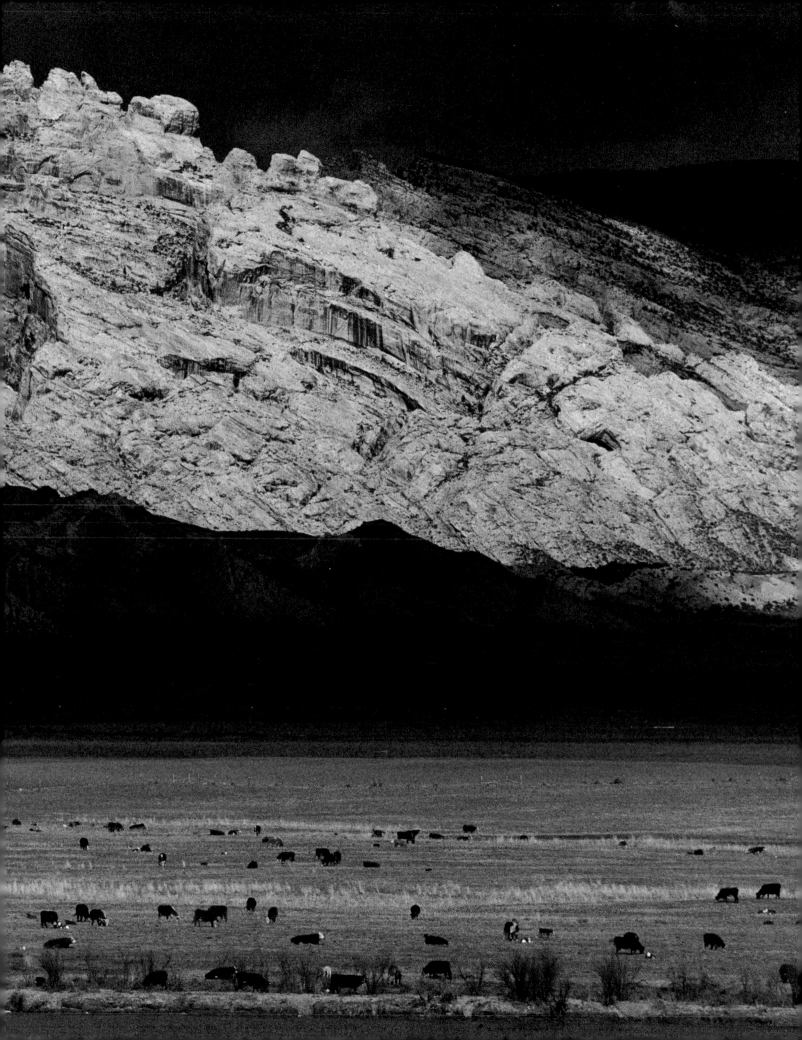

CANYONLANDS

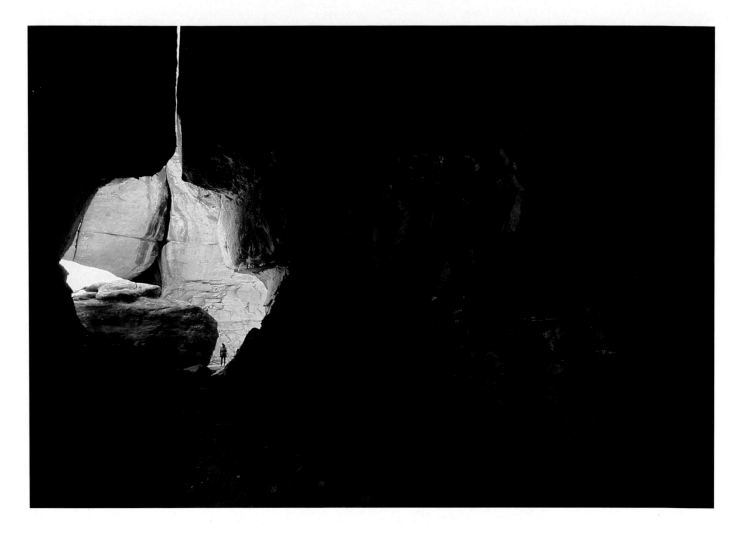

Along the slot section of Dead Horse Point State Park's Joint Trail, colossal rocks overpower human forms. Slots occur at joints where water has sliced through the fine-grained sandstone.

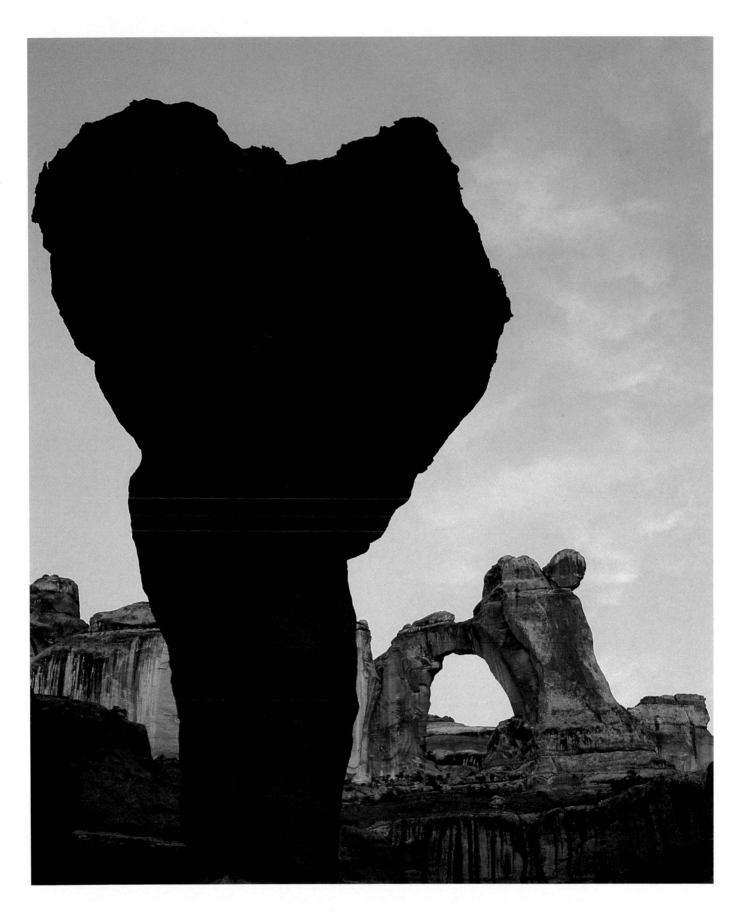

■ *Above:* Dawn illuminates Angel Arch, one of Arches National Park's most visited landmarks. The shadowed hoodoo—or natural column of rock—is called Molar Rock. ■ *Overleaf:* Dead Horse Point lies above a Colorado River gooseneck. The meandering pattern recalls when the river flowed on a relatively flat plain.

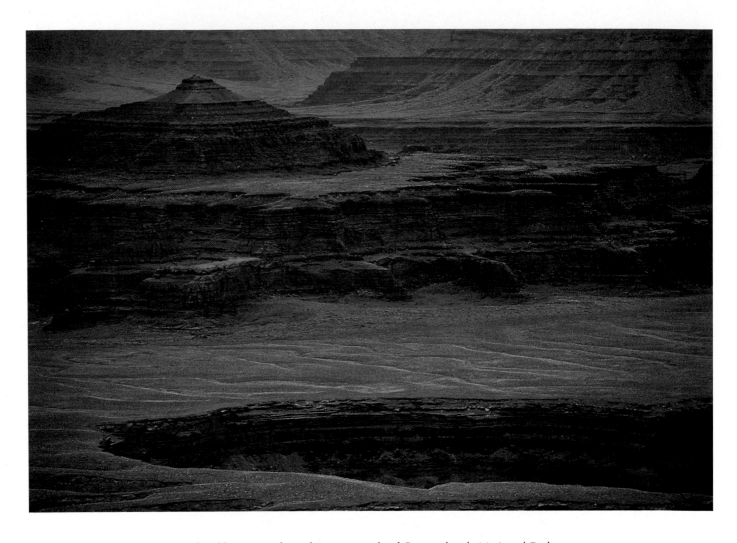

Island buttes such as this one north of Canyonlands National Park rise unexpectedly out of the bedrock mesa. Bedrock, either exposed or covered by loose sand, clay, or soil, is the solid rock which forms the hard crust of the earth.

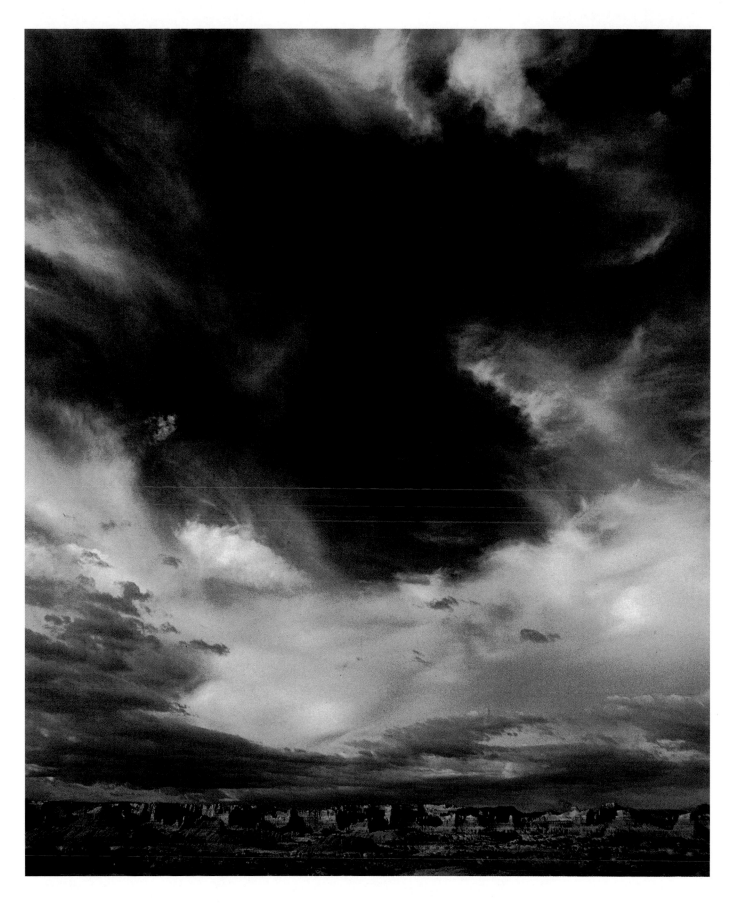

A tempestuous sky reels above The Needles, on the east bank of rugged Cataract Canyon. The same conditions which created the landscape at Arches—salt forcing its way up against overlying layers of rock and subsequent erosion—were at work in The Needles district of Canyonlands.

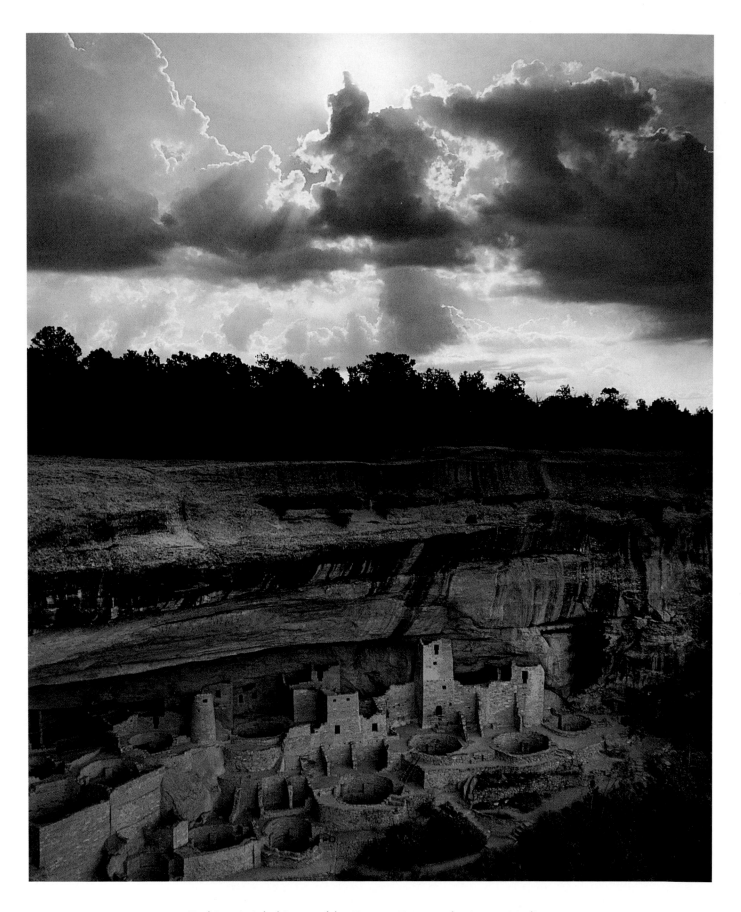

Prehistoric inhabitants of the Canyon Country, the Anasazi Indians
left behind many remnants of their highly sophisticated culture.
Built in the 1200s, Cliff Palace in Mesa Verde National park is one
of their most famous architectural achievements.

ANASAZI

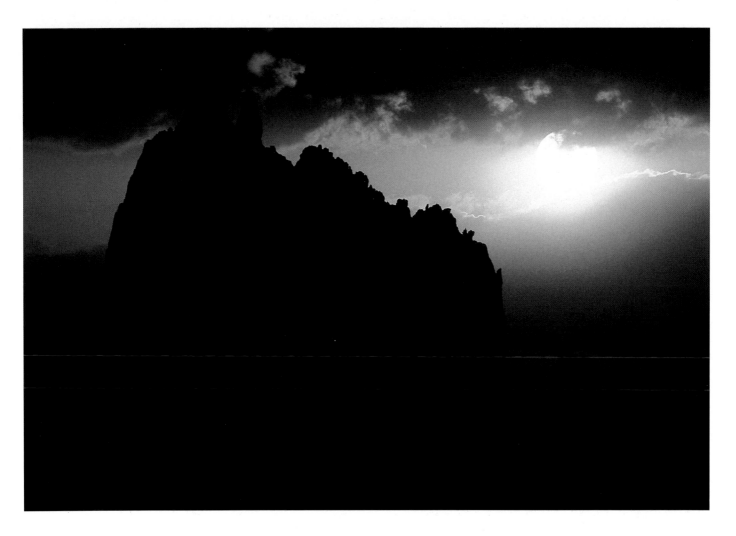

An ancient volcanic plug known as Ship Rock is a landmark of the
Four Corners region, where most Anasazi ruins are concentrated.
By 1300 A.D., the Anasazi abandoned this high plateau country.

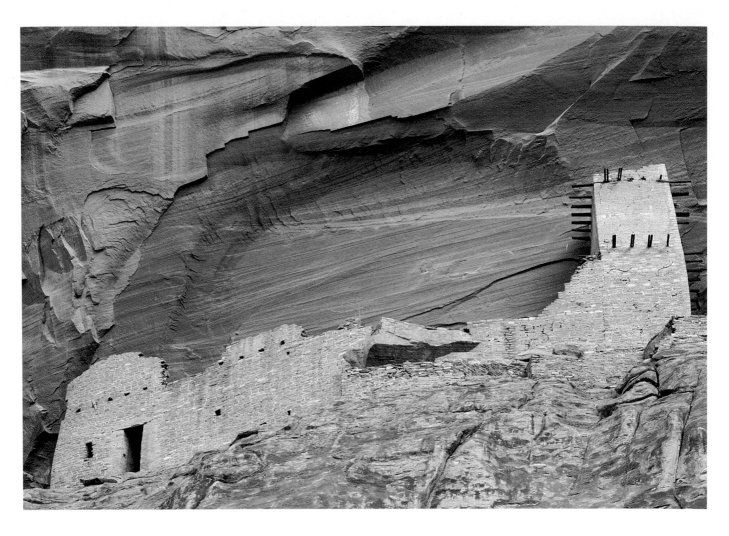

The Anasazi people lived in Mummy Cave in Arizona's Canyon de Chelly National Monument from roughly 100 A.D. until they abandoned the canyon for unknown reasons in the 1300s.

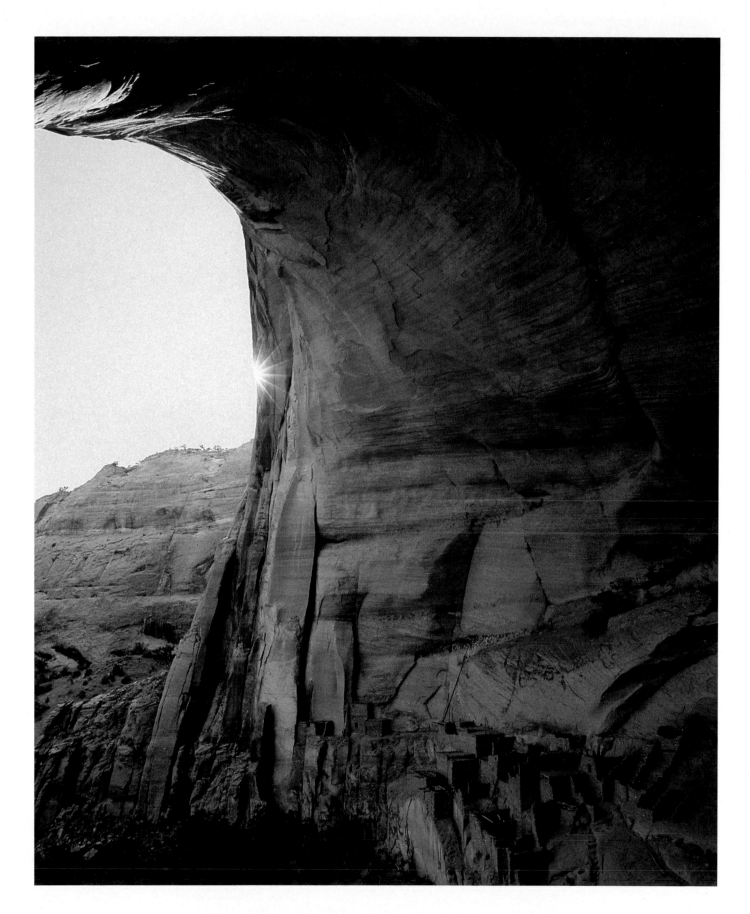

■ *Above:* Ruins at Betatakin in Navajo National Monument help tell the Anasazi story. Archeologists believe those living here migrated south to the Hopi mesas, while others moved southeast toward the Rio Grande. ■ *Overleaf:* Intermittent streams sculpt labyrinthine passageways in the sandstones of Canyon Country.

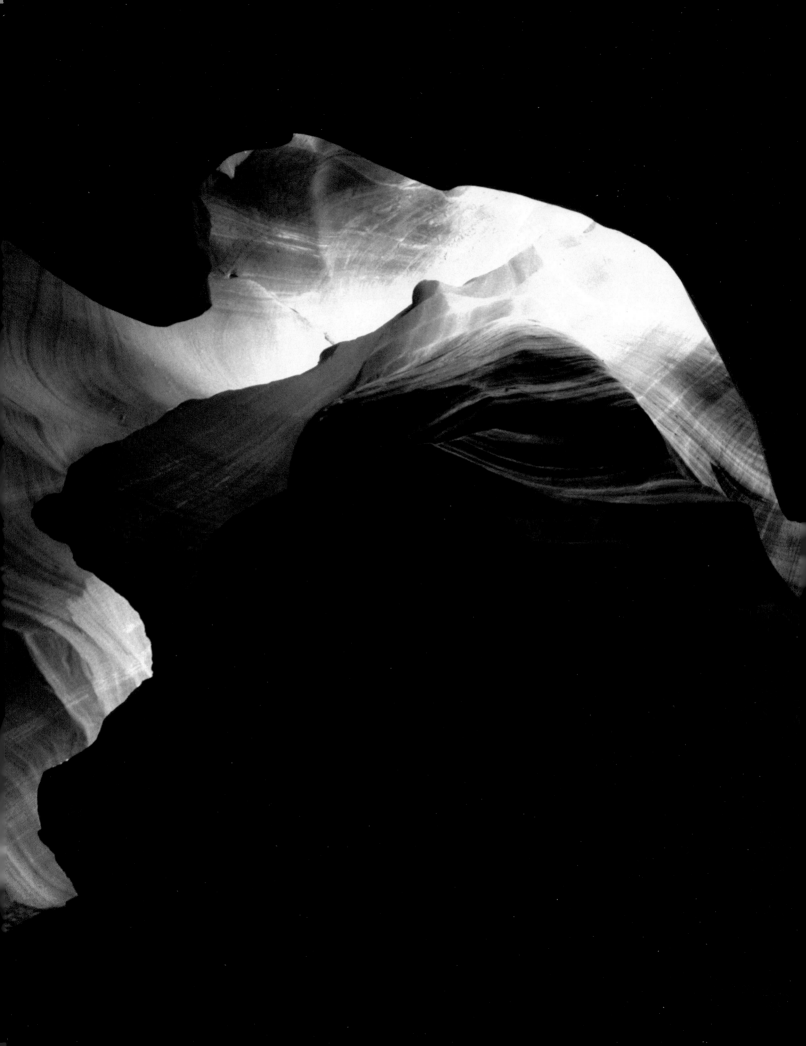

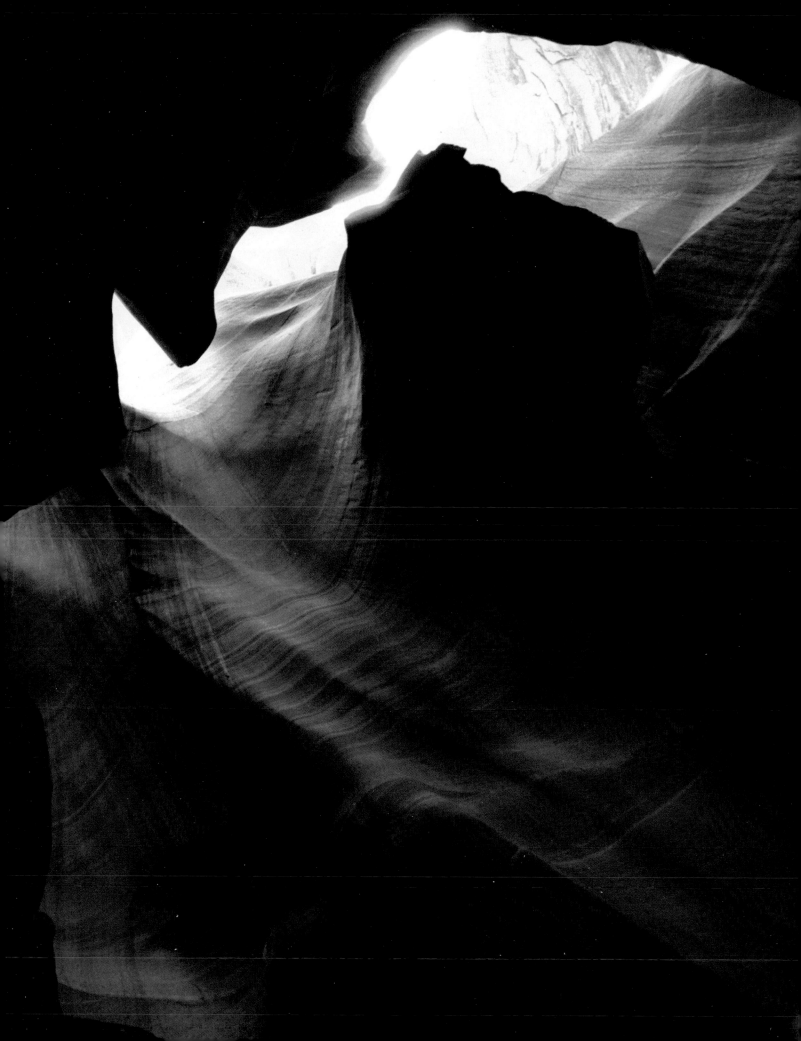

MONUMENT VALLEY

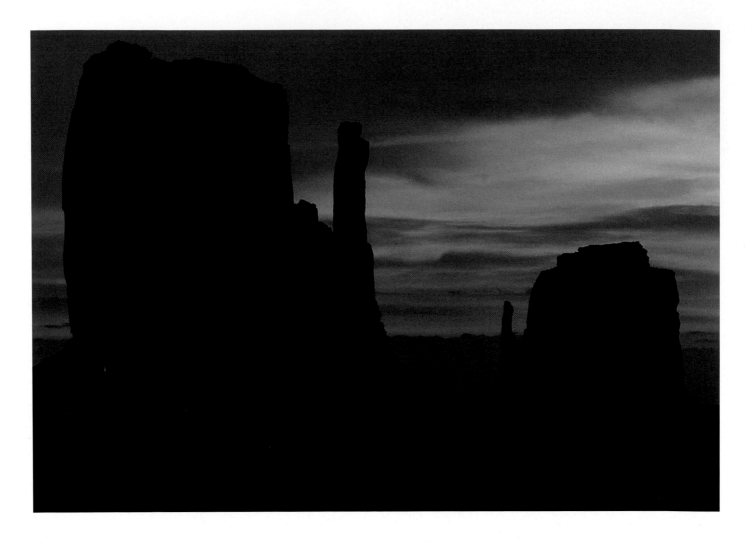

The familiar East and West Mittens stand at the entranceway to Monument Valley Tribal Park, part of the sixteen million-acre Navajo Reservation, located in Arizona, Utah, and New Mexico.

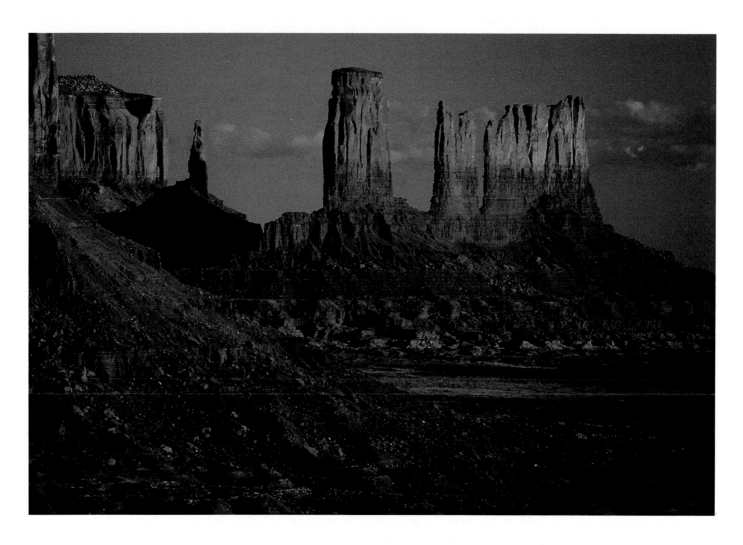

■ *Above:* The sandstone rock sculptures of Monument Valley, with pedestals of Organ Rock Shale, go by such fanciful titles as "Stagecoach," "Bear and Rabbit," and "Castle Rock." ■ *Overleaf:* The Navajo took up sheep raising in the area near Artist's Point after the Spanish introduced the animals in the 1500s.

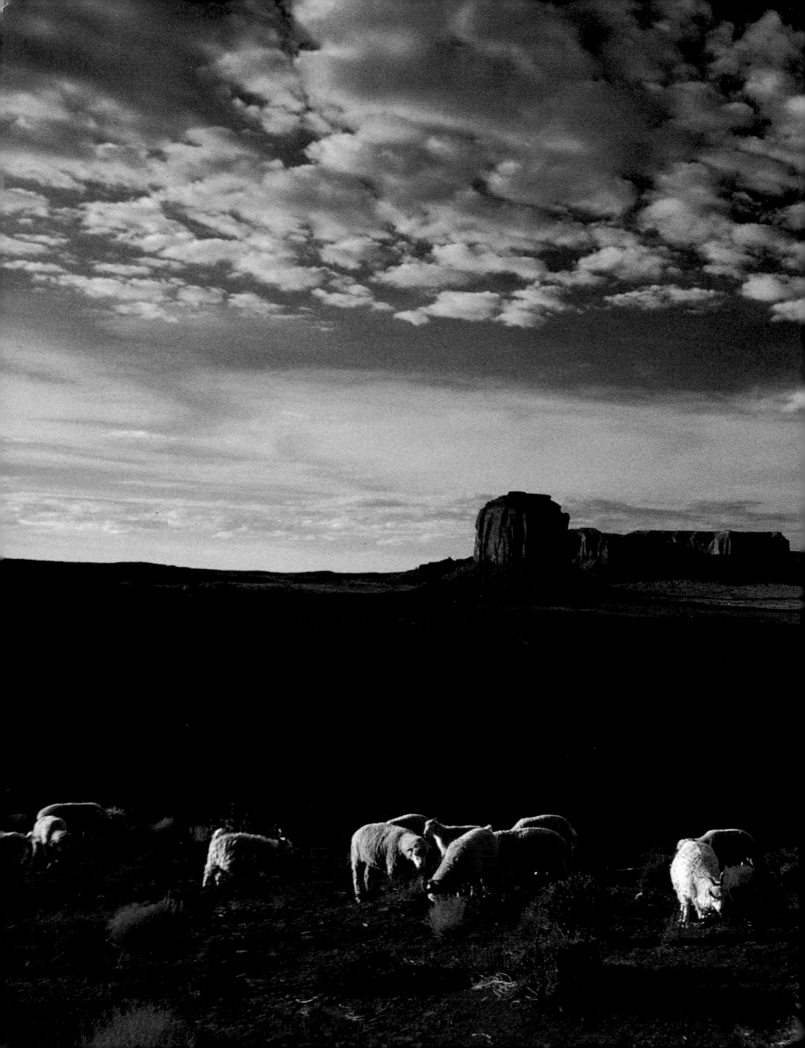

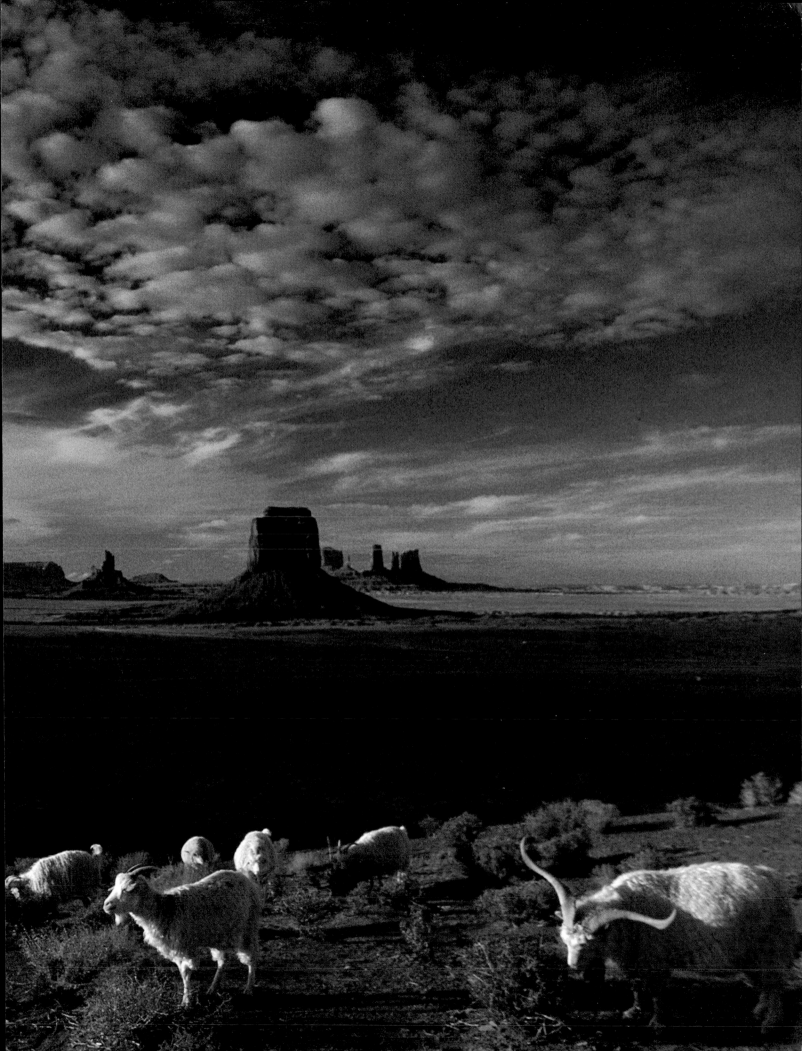

GLEN CANYON

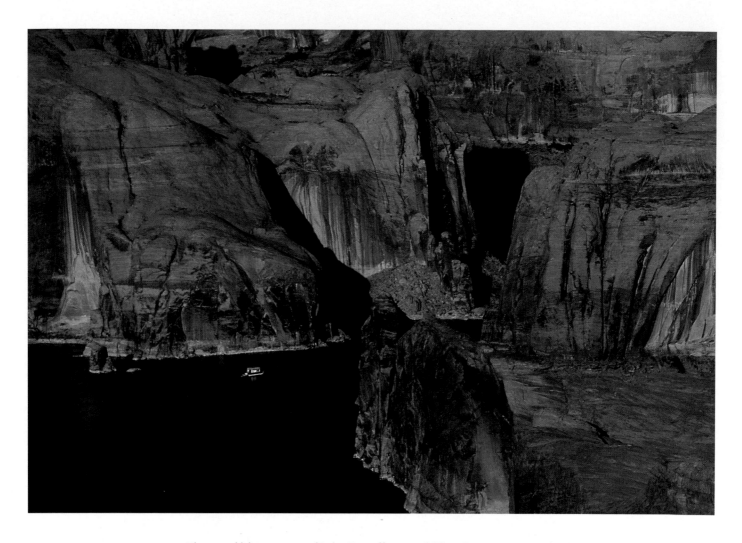

The royal blue waters of Lake Powell, part of Glen Canyon National
Recreation Area, spring from the combined forces of nature and
technology. This 186-mile stretch of the Colorado River was turned
into a reservoir when Glen Canyon Dam was completed in 1963.

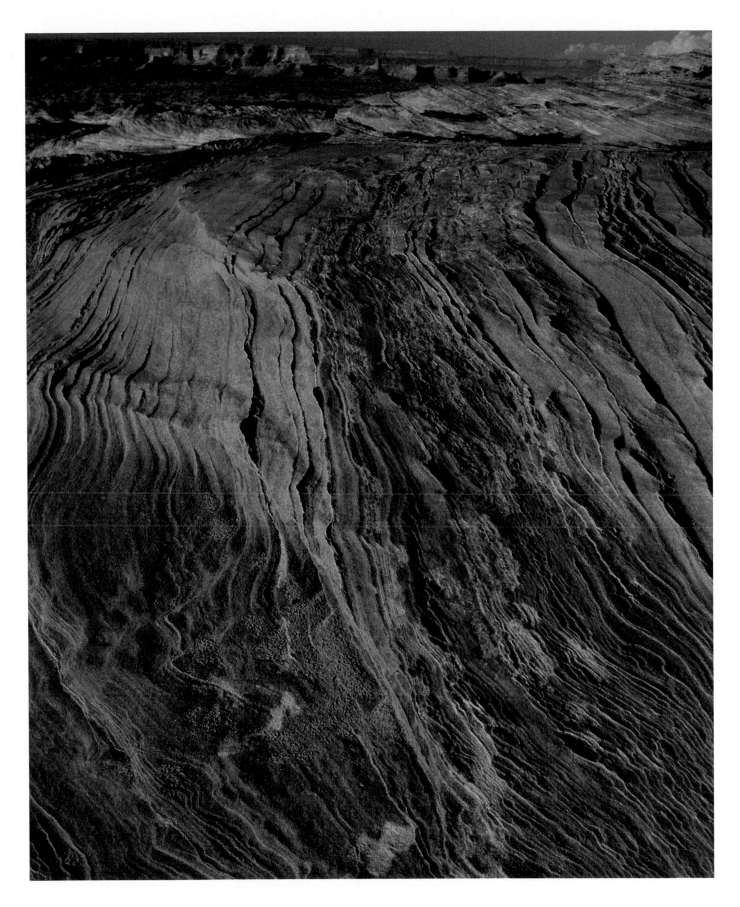

Here at historic Hole-in-the-Rock, Mormon pioneers struggled to cut a road through the steep rock walls of Glen Canyon, so they could ferry their wagons across the Colorado.

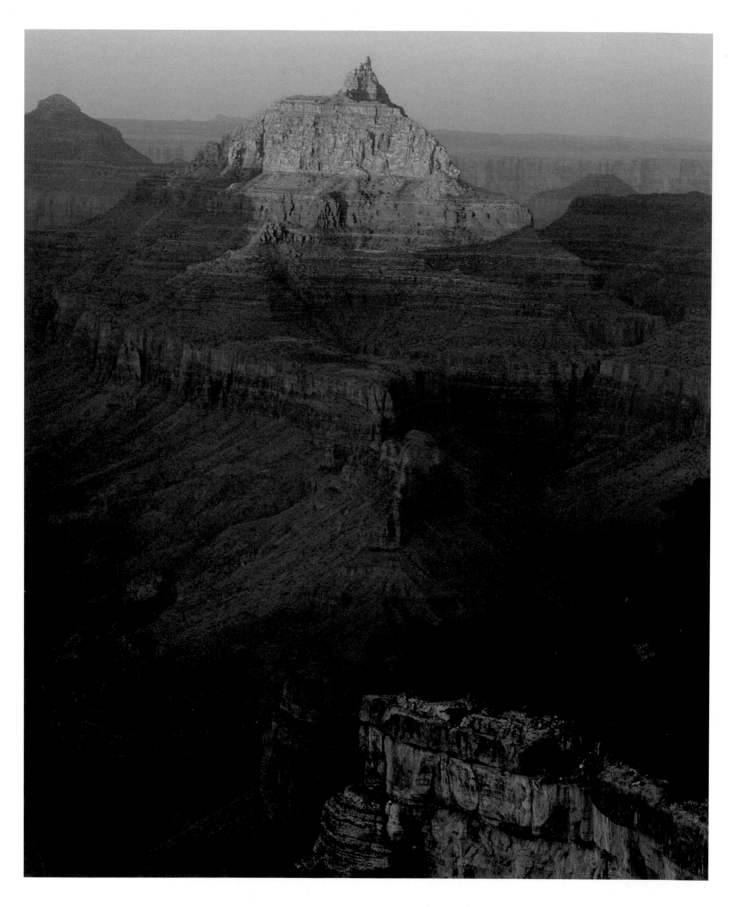

From Grandview Point on the Grand Canyon's South Rim, visitors can watch the canyon's changing moods and colors. For over four thousand years, the Anasazi, Cohonina, and Cerbat Indians have intermittently made the Grand Canyon their home.

GRAND CANYON

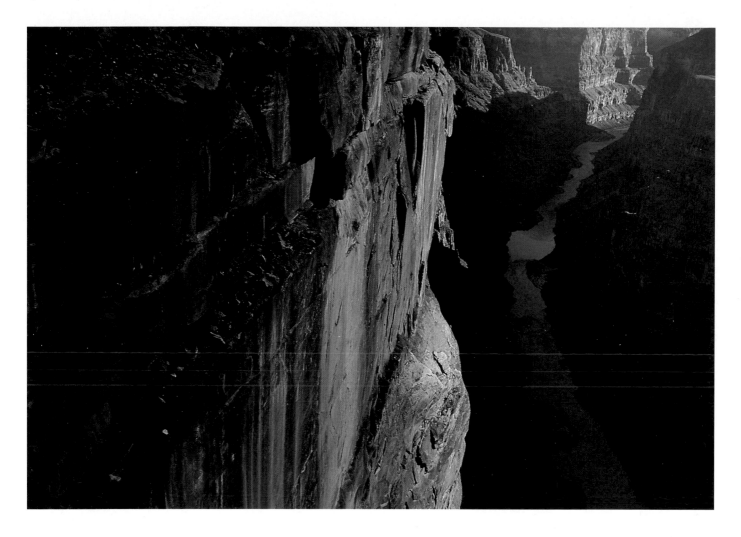

Toroweap Point on the Grand Canyon's North Rim drops straight down three thousand feet to the Colorado River, which cuts through layers of rock deposited as many as 1.7 billion years ago.

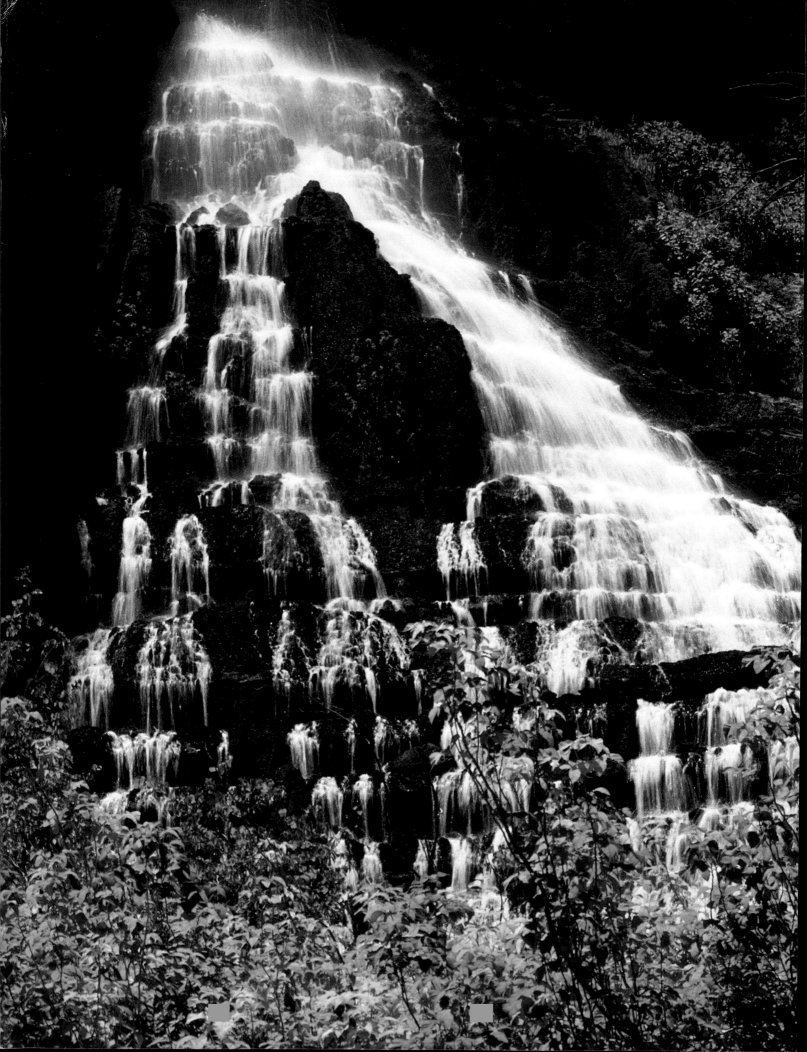

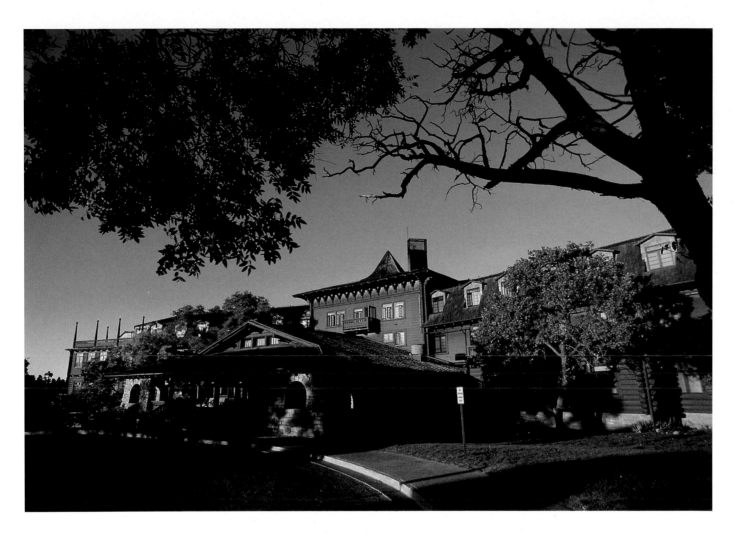

■ *Left:* At Vasey's Paradise in Marble Canyon, water moving through porous sandstone reaches impenetrable rock and gushes out of the canyon wall. ■ *Above:* El Tovar Hotel was built on Grand Canyon's South Rim in 1905. ■ *Overleaf:* Since 1950, more than 250,000 people have floated down the Colorado.

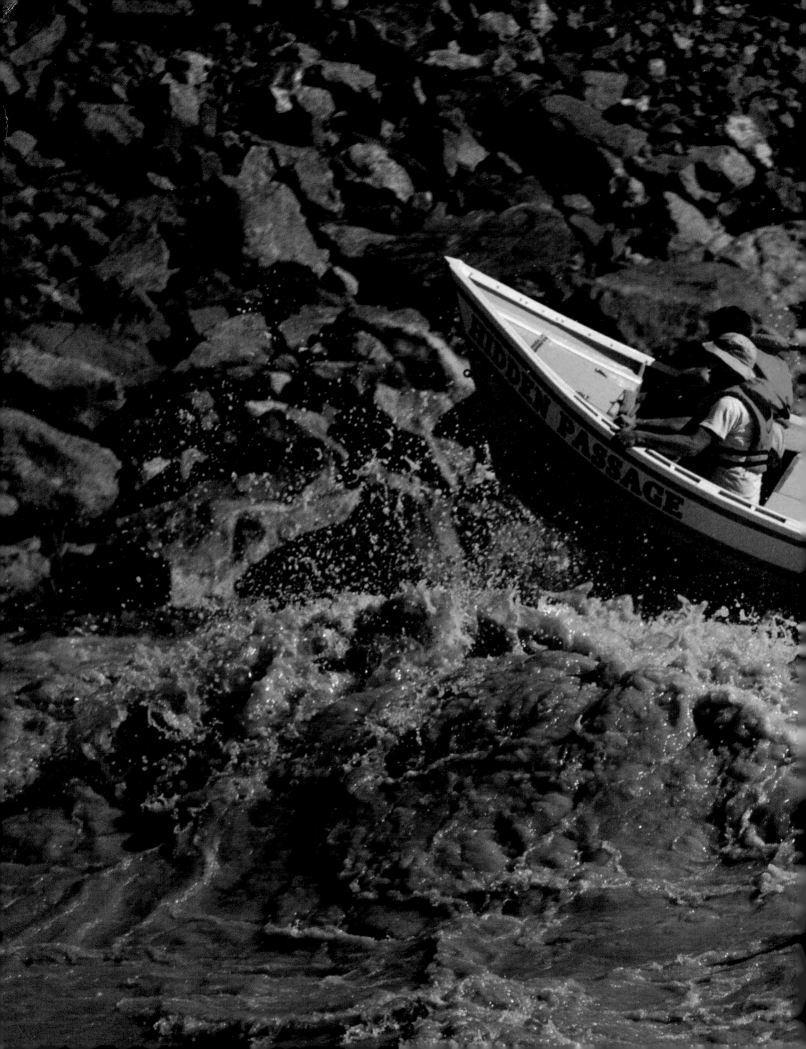

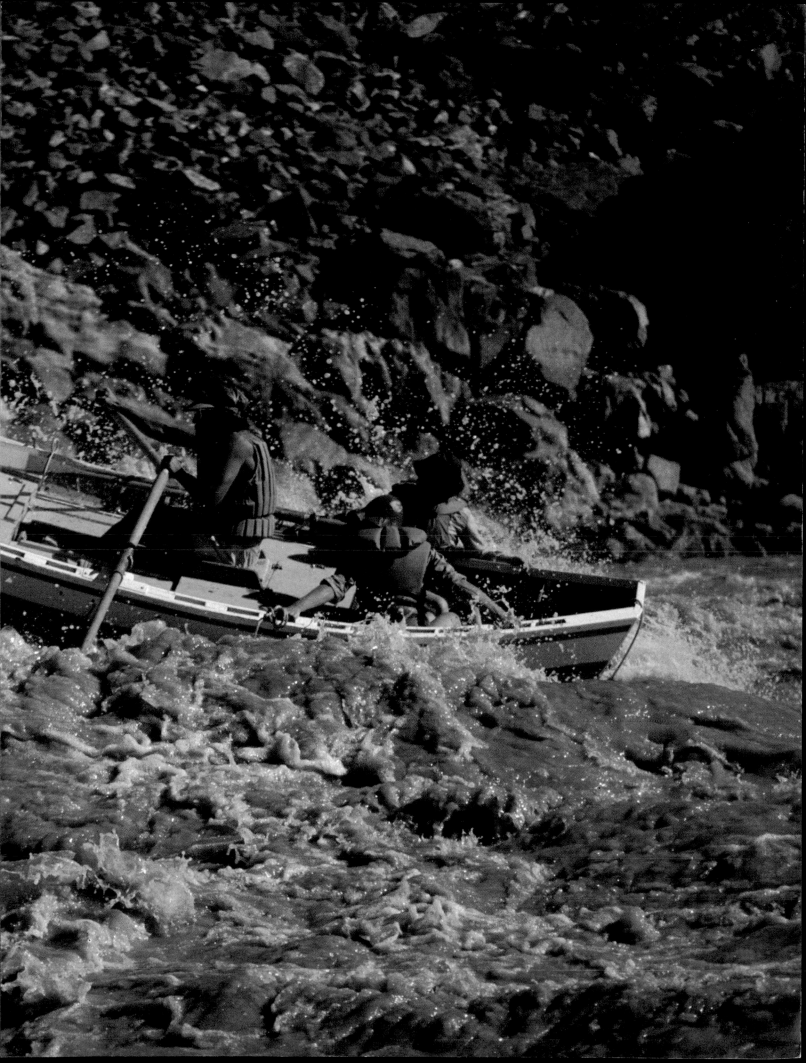

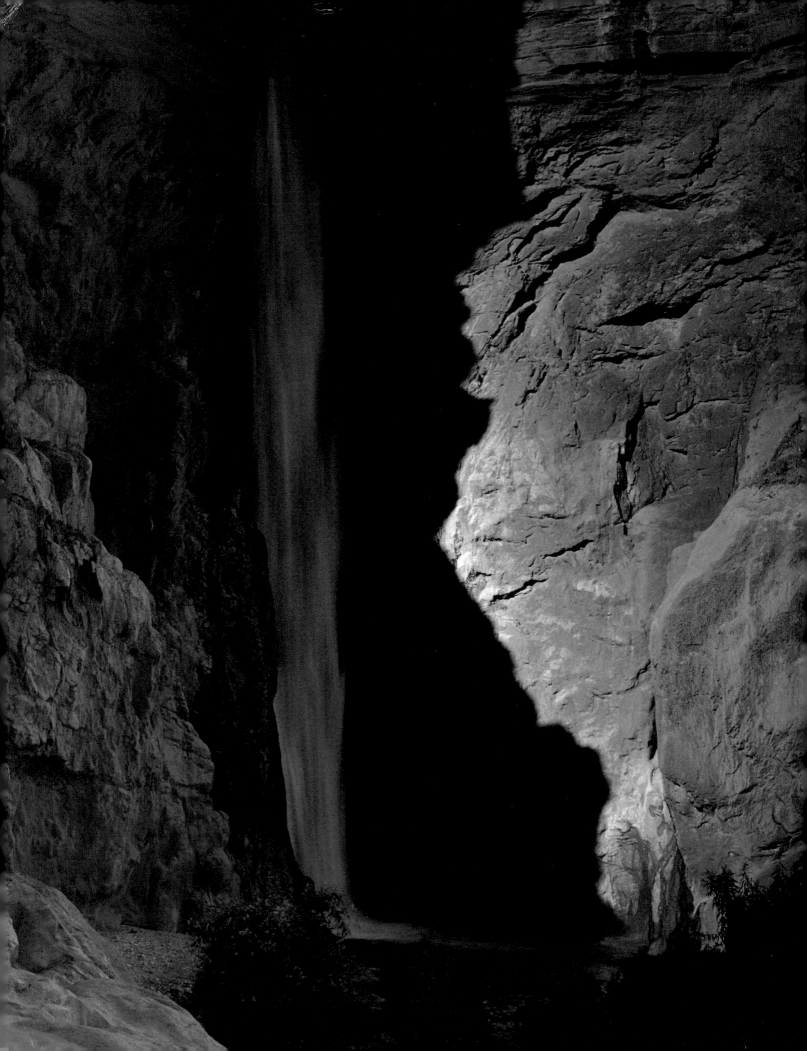

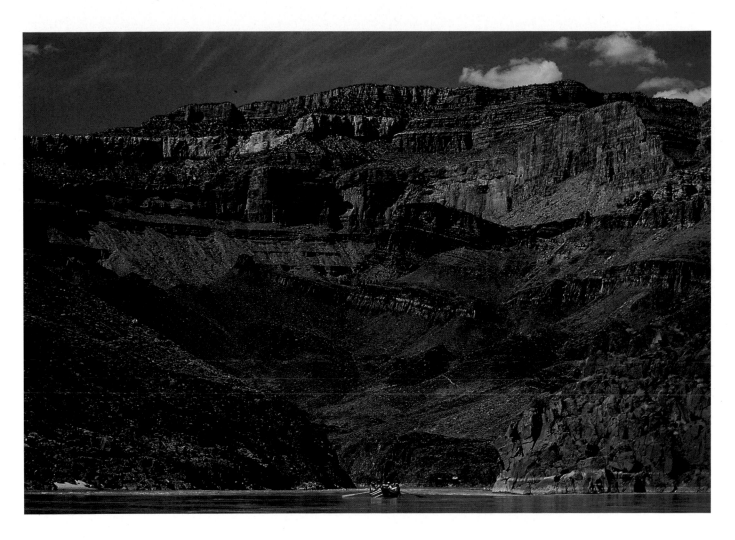

■ *Left:* More than one hundred feet high, Deer Creek Falls is a popular stopping point for river-runners. ■ *Above:* Nearly a third of the total geologic history of the earth is dramatically recorded on the stratified rock walls of the Grand Canyon. ■ *Overleaf:* Erosion does its work from above as well as below the canyon's rim.